## Meet the Masterpieces

# LEARNING ABOUT ANCIENT CIVILIZATIONS THROUGH ART

### by Bobbi Chertok, Goody Hirshfeld, and Marilyn Rosh

D1501588

SCHOLASTIC
PROFESSIONAL BOOKS

New York • Toronto • London • Auckland • Sydney

Cover design by Vincent Ceci
Book design by Patricia Isaza
Illustration by Jim Ceribello

ISBN 0-590-49505-4

12 11 10 9 8                    5/9

Printed in the U.S.A.

*To the thousands of schoolchildren whose curiosity and energy*

*have helped shape the Living Art Seminars program; to their*

*creative teachers, who have been a source of encouragement;*

*and to our grandchildren, the next generation of art lovers.*

# ACKNOWLEDGMENTS

◆◆◆◆◆◆◆◆◆◆◆◆◆◆◆◆◆◆◆◆◆◆◆◆◆◆◆◆◆◆◆◆◆◆◆◆◆◆◆

The authors wish to express their deepest appreciation to Lenore Roland for her intelligent help and generous editorial assistance, to Don McVicker for his expert comments on the Maya civilization, and to Miriam Gilsen for her enthusiastic formatting and preparation of the text.

We sincerely thank our husbands, who patiently read the chapters, gave valuable suggestions, and provided us with unwavering support.

# ABOUT LIVING ART SEMINARS

◆◆◆◆◆◆◆◆◆◆◆◆◆◆◆◆◆◆◆◆◆◆◆◆◆◆◆◆◆◆◆◆◆◆◆◆◆◆◆

In 1973, Bobbi Chertok, Goody Hirshfeld, and Marilyn Rosh created Living Art Seminars to bring fine art into the classroom, making it fresh, fun, and relevant to each and every child.

Today, thousands of elementary schoolchildren see, hear, and touch art through Living Art Seminars. With Living Art Seminars, they visit museums to discover the excitement and beauty of art. The Living Art Seminars approach places art in its historical context and promotes respect for and understanding of different cultures. It is designed to stimulate critical thinking, especially the skills of observation, sequencing, speaking, listening, and reasoning, and to impart the message that all children can be creative appreciators of art. As *The New York Times* has observed, "With the help of Living Art Seminars, students are discovering that art is a lot closer and more fun than they had imagined." Over the years, Living Art Seminars programs have been funded by numerous state and local grants.

In 1992, the three founders of Living Art Seminars captured some of their time-tested techniques in *Meet the Masterpieces: Strategies, Activities, and Posters to Explore Great Works of Art* (Scholastic). This second volume of *Meet the Masterpieces*, which focuses on the artistic expression of ancient cultures, presents eight more of the world's most treasured pieces and an array of creative activities designed to make them come alive for your students.

# CONTENTS

◆◆◆◆◆◆◆◆◆◆◆◆◆◆◆◆◆◆◆◆◆◆◆◆◆◆◆◆◆◆◆◆◆◆◆◆◆◆◆◆◆

# A NOTE TO THE TEACHER

◆◆◆◆◆◆◆◆◆◆◆◆◆◆◆◆◆◆◆◆◆◆◆◆◆◆◆◆◆◆◆◆◆◆◆

You are about to introduce your students to eight masterpieces of art. Not one of these magnificent works of art is signed. Yet each one was produced by an artist or artists living in a culture in which art had achieved great importance. Each masterpiece has unusual power, carries a sense of mystery, and demonstrates technical excellence. When you explore these treasures of ancient art with your students, you will be imagining life at different times and in different places. As they learn to appreciate these works, your students will come to a greater understanding of the cultures that produced them.

The art collected in this book spans eight cultures, five continents, and thousands of years of human history. The featured works include:

## ◆ Prehistoric Art:
Wall Painting from the Hall of Bulls, Lascaux Cave, Lascaux, France, circa 15,000 B.C.

## ◆ Minoan Art:
Fresco of Bull Leapers, The Palace of Knossos, Crete, Greece, circa 1500 B.C.

## ◆ Egyptian Art:
Royal Throne of King Tutankhamun, Valley of the Kings, Egypt, circa 1325 B.C.

## ◆ Chinese Art:
Clay Army of the Emperor Qin, Xian, China, 210 B.C.

## ◆ Pompeian Art:
Double Portrait Wall Painting, Pompeii, Italy, circa 79 A.D.

## ◆ Maya Art:
Polychrome Vase of Ball Player, Yucatan, Mexico, 600-800 A.D.

## ◆ Pueblo Art:
Wall Painting with Lightning Man, Kuaua Kiva, New Mexico, U.S.A., circa 1200 A.D.

## ◆ Benin Art:
Bronze Plaque of Mounted King and Attendants, Court of Benin, Nigeria, 1550-1680 A.D.

These masterpieces range in size from the huge panorama of bulls in the Lascaux Cave to the beautiful Maya vase, which can be held in one hand. They include the life-size sculptures of the Chinese clay army, the exquisite 19-inch plaque that hung on the palace wall in Benin, and the breathtaking golden throne upon which the teenage King Tutankhamun sat. The bull-leaping fresco decorated a room in the palace of the King of Crete, while the Pueblo mural was created for a sacred room in a Native American settlement. The Roman double portrait, buried for centuries under the ashes of Mount Vesuvius, may have commemorated the marriage of two young Pompeians.

Each of these works of art tells a story about a unique culture and the people who inhabited it. We invite you and your students to take a journey, through art, into eight new worlds.

# HOW TO USE THIS BOOK

◆◆◆◆◆◆◆◆◆◆◆◆◆◆◆◆◆◆◆◆◆◆◆◆◆◆◆◆◆◆◆◆◆◆◆◆◆◆◆◆◆◆◆◆

The book is divided into eight sections, each structured around a particular work of art and the culture that produced it.

The reproducible Time Line and Treasure Map at the back of the book relate to all the sections and will help students place the works they are studying in time and on the globe. Following them is a Word Bank, also reproducible, which lists and defines key terms used in each lesson. Students can "withdraw" words from the bank when focusing on a particular culture—to be used in word games or creative writing—and "deposit" new words as they encounter them. At the end of the book you will also find a list of suggested Culminating Activities and a Bibliography that offers additional resources for teachers and students.

Each of the eight thematic sections in the book in turn consists of five elements:

### ◆ The Discovery

Perhaps the most exciting aspect of the works collected here is that *all* of them were unknown and buried until modern times. The Discovery pages, which can be reproduced and distributed to the class, tell the stories of how the masterpieces came to light. As they learn about the discoveries, students will become familiar with the work of archaeologists, linguists, and historians.

### ◆ Exploring the Culture

The Exploring the Culture readings, also reproducible, provide background information for each work of art. They answer the questions *who, where, when,* and *how.* Who were the people who created this art? Where and when did they live? And how did they live? In a discussion of time and place,

you may find it helpful to refer to the Time Line and Treasure Map.

### ◆ Exploring the Art

These portions of the book are the teacher's guide and the heart of the learning experience for you and your students. The questions included in Exploring the Art are designed to encourage students to observe, react, query, imagine, articulate ideas, and express feelings. Your students' responses to the open-ended questions and your own follow-ups will often lead to surprising and fascinating detours.

Each Exploring the Art section is broken down into two segments:

### *First Glance*

The questions included under First Glance tap students' first impressions and powers of observation. By encouraging students to respond freely to these initial inquiries, you will build the self-assurance that will enable them to rely on their critical thinking skills as they move on to the more challenging questions in Closer Look.

### *Closer Look*

The questions and comments in Closer Look are designed to communicate more particularized information about the work and the culture in which it was created. They highlight different themes in the art and the techniques employed by the artists. You may wish to lead the discussion in two short sessions rather than one long one; the response of your class will guide you. Keep in mind that some of the information supplied in Closer Look may be useful to you as background material but not

essential for your students. As you discuss different aspects of the work, you may find it helpful to relate or compare the art to a real-life situation or to a story the class has read. Finally, you need not ask every question—just stay with the piece for as long as the students find their visit interesting and relevant.

### ◆ Reproducible Activity Pages

These pages present creative writing and drawing experiences relating to the art and cultures students are exploring. They encourage students to connect the ideas in the masterpieces to their own world.

After distributing an activity page, you should discuss the instructions with the class. Students should then be given maximum freedom to respond creatively. After students complete a drawing activity, you might have them expand their ideas on larger paper or in three-dimensional form.

### ◆ Extension Activities

Each thematic section includes a list of suggested Extension Activities aimed at building critical thinking skills and extending the learning experience across the curriculum. Some relate to geography, others to math, research, or writing. Many of the activities are designed to be done by several students working together; the groups can then share their results with the rest of the class.

### Some hints:

**1.** Relax! An extensive knowledge of art is not required. The goal of these lessons is simply to appreciate the featured works and cultures through the use of everyday critical thinking skills.

**2.** Take a good look at each work of art before you introduce it. Keep track of your own first impressions. Do you have any questions about the art? Jot them down.

**3.** Read over the entire section relating to a work of art before you begin the lesson. Try to find some threads that will connect the art with the interests of your students. Make a note of the activities you think will excite them.

**4.** As you discuss each masterpiece, you will want to have the poster displayed in a prominent place in your classroom. You might want to make "frames" and hang the works of art in an area where students can gather around them, as in a gallery.

**5.** In exploring the art with your class, keep in mind that there are no "wrong" answers for you or your students. The explanations of the art contained in this book in many instances represent archaeologists' or art historians' "best guess." Your students' interpretations may be just as close to the truth as theirs, since experts often disagree as to how or why a particular work was created. Divergent responses should be encouraged!

For example, when presenting the prehistoric cave painting, you might ask: Why do you think the artist painted the bulls so large and the horses so small? We have scientific evidence that 17,000 years ago, bulls *were* huge and horses relatively small. It would be equally valid, though, for your students to say that the bull was probably very important to ancient peoples and may have been worshipped by them. Not only might such a response be correct, but it would demonstrate that your students were using their critical thinking skills to relate to the art. These connections are the whole point of the discussion, for they add richness and meaning to the experience of viewing art.

**6.** Historical and technical terms used in the reproducible students' sections with which students may be unfamiliar are defined in context and also appear in the Word Bank. Pronunciations are supplied directly after proper names or words that students might find difficult to pronounce.

**7.** Have your students collect the Discovery and Exploring the Culture handouts in a folder as a record of the works and cultures visited. You might have them add illustrations and creative writing for each lesson.

**8.** For additional background information about the cultures featured in this book, consult the Bibliography, or check with your school or local library. There may be museums in your vicinity where you can find out more about these cultures and see other examples of their art.

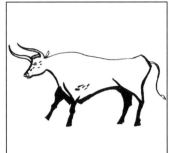

# DISCOVERY:
## *Wall Painting from the Hall of Bulls*

◆◆◆◆◆◆◆◆◆◆◆◆◆◆◆◆◆◆◆◆◆◆◆◆◆◆◆◆◆◆◆◆◆◆◆◆◆◆◆◆◆◆◆

**Lascaux (las-COE) Cave, Lascaux, France, circa 15,000 B.C.**

On September 8, 1940, a boy named Marcel Ravidot (RAV-i-doe) and his friends were hiking in the Lascaux hills in southern France. Suddenly, they noticed that Marcel's dog, Robot, was missing. They called, and heard a strange muffled bark that seemed to come from under the ground. As they approached the source of the sound, they discovered an opening in the earth near a fallen pine tree. Robot's barking came from there.

As Marcel started down the steep, slanting tunnel, he lost his balance and tumbled down into a dark cave. It was only with great difficulty that he rescued Robot. But he returned four days later to explore the underground cavern.

This time, Marcel and his friends had a lamp and some rope which allowed them to go further into the cave. As they raised the lamp to view their surroundings, enormous animals, red and black, yellow and brown, seemed to leap from the darkness. They realized that the bulls, bison, and deer they saw were painted on the walls of the 100-foot-long cavern. In other passages in the cave, they discovered paintings of deer that looked as if they were swimming across a stream, with only their heads showing above the water.

In school, Marcel had learned about paintings made by cave artists many thousands of years ago. Could the paintings he had found be the work of artists who lived in prehistoric times, before people had learned to write? Though he and his friends wanted to keep their "treasure" a secret, they knew they had made a very important discovery. They soon found out that the carvings and paintings were created during a time known as the Magdalenian (Mag-da-LEE-nee-en) Period, about 15,000 years ago.

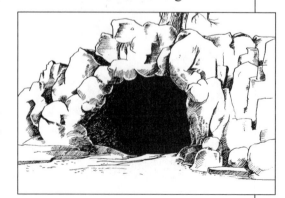

News of the Lascaux Cave spread quickly. Each day, hundreds of visitors came to view the prehistoric paintings. Proudly guiding them was Marcel Ravidot, the boy who discovered one of the greatest art treasures in France.

# EXPLORING THE CULTURE

A half a million years ago, the Ice Age began. Great sheets of ice covered many parts of Europe, Asia, and North America. For many thousands of years our early ancestors found shelter in caves. Because the caves were so dark and damp, people lived near the entrances. Sometimes they settled on overhanging rock ledges, where they could enjoy the sun on nice days—very much as a modern person would on a front porch.

However, some cave dwellers went deep inside the caves to paint and carve animals on the walls and ceilings. What led them into caves as black as night to create their art? So far, archaeologists (ar-kee-OL-o-jists) can only guess, but they are uncovering more and more clues all the time.

The cave artists were called Cro-Magnons (kroe-MAG-nens)—the first modern people. They probably looked very much like we do. Their brains were as large as ours. They were skillful with their hands and could make many kinds of tools. They lived together in family groups, or clans. There is no evidence of warfare. In fact, they probably knew how to cooperate peacefully with one another to get food and find shelter. They also knew how to use fire to make their lives easier and better.

Then, about 10,000 years ago, the ice sheets began to melt. The weather turned warmer. Rivers flooded and great thick forests came to cover the once frozen land. People stopped living in caves and began to build huts and houses. The old caves were forgotten and covered over as the landscape changed.

Today, these ancient caves are usually discovered by accident. Scientists are very interested in them because they provide valuable information about life in prehistoric times.

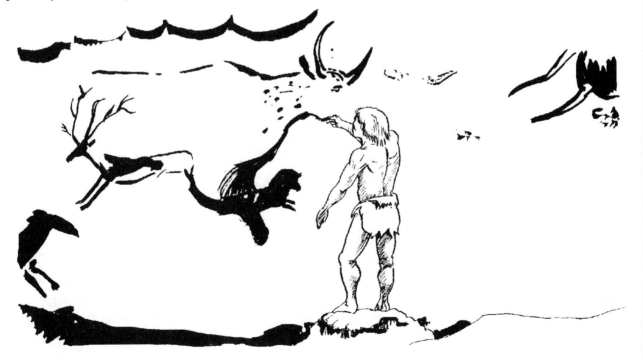

# EXPLORING THE ART

## *Wall Painting from the Hall of Bulls*

**Lascaux Cave, Lascaux, France**
**Circa 15,000 B.C.**

### ◆ First Glance

**Where were these animals painted?**
They were painted on the walls of the Lascaux Cave in the south of France. This scene is just one part of the largest cave painting ever found.

**How many animals can you identify? Can you guess how large they are in the painting?**
The two large bulls are 10 feet and 12 feet long. Each is about the length of a car. The horses in front of the bulls are different sizes, but the largest are 6-1/2 feet long, the height of a medium-size basketball player. The stags or deer running between the bulls are just over 2 feet, a little bigger than a classroom desk.

### ◆ Closer Look

**Do the same animals exist today? What are their modern relatives?**
The bull in the painting was called an aurochs and weighed over 2000 pounds. Its horns could be almost three feet long. Our modern bulls are related to this wild ancestor.

The most frequently painted animals in the Lascaux Cave were horses. Most of them were smaller than our horses today. They had bigger heads on thick necks and their manes stood up like a brush. Their tails were very long. Like all the animals painted on the walls, the horses were wild. Prehistoric people did not ride these horses or use them for work.

The stags were very similar to modern deer. They were painted smaller than their real size. These stags had pointy heads and antlers which grew fuller as they grew older.

**Why do you think cave artists painted these animals?**
Here are some possibilities: (1) The animals may have been part of an early magical religion. They were painted in a part of the cave that may have been a sanctuary where people could go to worship them. (2) Some archaeologists think the animals might have something to do with hunting. (3) Another idea is that the beauty of these huge, majestic animals inspired artists to paint them.

No one is certain why cave artists created this art. Because these paintings are prehistoric, they were painted before there was any written record of how people lived or thought. The exciting part is that your guesses might be as close to the truth as those of any expert.

**How did the artists show that the animals are moving?**
Look at the animals closely. They look alive and in motion. Though we see the side of the bull's head, his horns are twisted so we see both of them, as though he were coming toward us. A horse's ears are perked up as if listening for sounds. The stags' antlers branch out in all directions. One has legs that are spread out so it appears to be running.

**Do you think they were painted by the same artist? Do you think they were painted at the same time?**

A running horse is painted on top of one of the bulls. A bucking horse appears inside the lower part of the other bull. Animals overlap and some are not complete. Experts think these animals were painted by different groups of artists over different periods of time. But the later artists did not destroy what they found on the cave walls. They seemed to show respect as they added their own animals without destroying those already painted underneath.

**Who were the artists who painted on the walls?**

The artists were Cro-Magnon people, who are thought to have been as intelligent as modern men and women. The artists may have been considered so talented that they were given time off from hunting and everyday tasks to make these drawings for the benefit of the clan.

**Why did they choose this cave?**

Southern France has hundreds of caves, but the one at Lascaux is unique. The cave has a large chamber or "room" called The Hall of Bulls. It measures 55 feet long by 22 feet wide by 19 feet high. The walls and ceiling are gleaming white. The first artists to discover Lascaux found a large white surface on which to paint.

**How were the artists able to see in the cave?**

On the cave floor and tucked into cracks in the walls archaeologists have found over 100 lamps that were used by the artists when creating the paintings. Some were made of stone with animal fat on top and a wick of twisted twigs. Others were hollowed-out rocks which could hold fuel. A few were decorated with marks and designs. These lamps projected a flickering light on the cave wall, very much like a candle. Archaeologists have also found traces of charcoal in the cave, which could indicate that fires were lit as well.

**How did the artists get their paintings so high up on the walls?**

Archaeologists have discovered chips of wood and man-made holes full of clay in the walls of the cave. These two finds, plus the fact that the paintings are 13 feet above the cave floor, have led researchers to believe that the cave artists built scaffolding to stand on.

**How did the artists make their paints?**

The paints, or pigments, used in Lascaux were made from colored stones. Some of the stones were found inside the cave and some were as far away as 25 miles. The different-colored stones had to be gathered and ground into powder. The colors used at Lascaux were yellow, red, brown, white, and black. Archaeologists have uncovered solid blocks of pigment which were used by the cave artists in the same way you use crayons.

**How did the artists get the paint on the walls?**

The artists painted with brushes made from animal hair and plant fibers, and with sponges made from fur. In other caves, artists placed their hands against the cave wall and blew pigment through a hollow bone, creating an outline of color around their hands.

**13**

# Draw a Wild Thing

Cave artists often used the bumps and cracks on the cave walls as part of their painting. Draw a real or imaginary animal (or animals) using the bumps and cracks shown below.

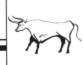

# Dig Detective

◆◆◆◆◆◆◆◆◆◆◆◆◆◆◆◆◆◆◆◆◆◆◆◆◆◆◆◆◆◆◆◆◆◆◆◆◆◆◆◆

Archaeologists are like detectives. They search for artifacts, which are objects made by humans. Pretend you are an archaeologist. Below are three artifacts you have found in a cave. Record your observations about each one, the way an archaeologist would. What material could it be made of? How big do you think it is? Describe its shape and any important features. Can you guess how it was used? What would we call it today?

1. Material:_____

Size:_____

Description:_____

_____

_____

Possible Use:_____

Modern Name:_____

2. Material:_____

Size:_____

Description:_____

_____

_____

Possible Use:_____

Modern Name:_____

3. Material:_____

Size:_____

Description:_____

_____

_____

Possible Use:_____

Modern Name:_____

Name:

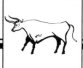

# Magdalenian Mall

◆◆◆◆◆◆◆◆◆◆◆◆◆◆◆◆◆◆◆◆◆◆◆◆◆◆◆◆◆◆◆◆◆

Archaeologists have determined that the Lascaux Cave was painted during a period of time from 17,000 to 13,000 years ago. They have named that time the Magdalenian Period.

If you went into a modern shopping mall today, you could probably find everything you need to live comfortably. During the Magdalenian age, people had to rely on their natural environment for food, clothing, and shelter. The environment was their "shopping mall." Fill in the blanks below.

**Now:**

1. Some of our clothes are made of _____

2. Some of our tools are _____

3. Some of our snacks are _____

4. We get our light from _____

5. Some of our jewelry is_____

**Then:**

1. Their clothes may have been made of _____

2. Their tools may have been _____

3. Their snacks may have been _____

4. They probably got light from _____

5. Their jewelry may have been _____

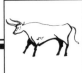

# EXTENSION ACTIVITIES

◆◆◆◆◆◆◆◆◆◆◆◆◆◆◆◆◆◆◆◆◆◆◆◆◆◆◆◆◆◆◆◆◆◆◆◆◆◆◆

**1.** Have your students pretend they have discovered an underground cave. On the walls are paintings revealing a lost civilization. Ask them to write and illustrate a journal telling of their adventure. By analyzing the paintings, they can deduce the customs and beliefs of the lost civilization. What was important to these people? Why did they disappear?

**2.** Many of the animals depicted by prehistoric artists are now extinct. Others are endangered species. Have the students research the woolly mammoth, cave bear, aurochs, ibex, and other early animals. Then have them collaborate on a mural depicting each in its natural habitat. Students can list key facts under each animal, such as what it ate and when and why it became extinct.

**3.** In the Lascaux Cave, archaeologists dug through layers of earth to find garbage that had been thrown away thousands of years ago. They discovered animal bones, arrowheads, flint, and shells, all of which provided clues about how early people lived.

Have your class collect one week's trash in a large plastic bag. Ask other classes to do the same. (Collect only paper items—no food or glass.) Then have groups of students "excavate" the trash from the bags and record their observations. Students might consider the following: What things were used first? What activities took place? What does the garbage reveal about the students? Were there differences among the classes?

**4.** Did your students notice the series of marks above the aurochs' muzzle? This is one of over 400 such markings in the Lascaux Cave. Some of these signs consist of dots; others are branching shapes or rectangles with boxes inside. Some experts think the signs represent weapons or traps. Others believe they gave instructions or directions, or may have been signatures of sorts. Could they have been the beginning of a written language?

Ask your students to "invent" a new form of writing that uses dots, lines, and shapes instead of letters. Have them use their invention to sign their names or to make signs that might have had meaning for prehistoric peoples.

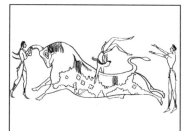

**Minoan Art**

# DISCOVERY:
## *Fresco of Bull Leapers*

◆◆◆◆◆◆◆◆◆◆◆◆◆◆◆◆◆◆◆◆◆◆◆◆◆◆◆◆◆◆◆◆◆◆◆◆◆◆◆◆

**The Palace of Knossos (NOS-us), Crete, Greece, circa 1500 B.C.**

Crete is an island in the Mediterranean sea. In ancient times, Crete was ruled by the powerful King Minos (MY-nus). King Minos built many cities with large palaces. The most splendid of all his palaces was at Knossos (NOS-us).

About 3000 years ago, the great civilization led by King Minos suddenly disappeared. Some scholars think a volcano caused terrible earthquakes all over the Mediterranean. Clouds of dust from the volcano fell on Crete and covered the fields. A great tidal wave washed over the island.

The achievements of King Minos lived on in many legends. It was said that his palace at Knossos had an underground labyrinth (LAB-eh-rinth), or maze, of many twisting paths. No one who entered the labyrinth could ever find the way out. At the center of the maze lived a terrible monster called the Minotaur (MIN-uh-tor). It had the head of a bull and the body of a man.

According to a famous myth, every nine years, Minos made the king of Athens send him seven young men and seven young women to throw into the maze. Each time, they were eaten by the fierce Minotaur before they could find their way out.

One year, a brave and handsome Athenian prince named Theseus (THEE-see-us) accompanied the youths to Crete. When he arrived at the palace, Ariadne (ahr-ee-AHD-nee), the daughter of King Minos, fell in love with him. Ariadne gave Theseus a ball of thread to unwind as he made his way through the labyrinth. He killed the evil Minotaur and escaped by following the thread out of the maze.

An English archaeologist (ar-kee-OL-o-jist) named Sir Arthur Evans had read all the old myths and legends. What if there were some truth in these stories? In 1900, he began to dig in Crete and uncovered the palace at Knossos.

The palace had over 1200 rooms. Flights of stairs zigzagged back and forth between them. Indeed, the palace seemed like a huge labyrinth. The walls were decorated with frescoes, or paintings made on wet plaster. Everywhere were pictures and statues of bulls, which were considered sacred in the time of King Minos.

Evans spent more than 25 years excavating and restoring the ruins. He called the civilization he uncovered Minoan (meh-NO-un), after the great King.

# EXPLORING THE CULTURE

Crete is the largest of all the Greek islands. Wherever you go on Crete, you are not far from the sea. Almost 4000 years ago, ships from Crete sailed all over the known world. The island grew rich and powerful, trading with people in faraway lands.

The ruling families of Crete lived in great luxury. They built many-roomed palaces. Some palaces even had bathrooms with bathtubs. There were pipes under the floor to supply a constant flow of running water. One palace had a flush toilet. The plumbing system of ancient Crete was not equaled until modern times.

Most people of this culture did not live in palaces, but rather in towns and villages, where they carried on their trades. Potters made storage pots for olive oil, grain, and wine. These clay pots were so large a person could fit inside. The bakers baked a special kind of bread that was as hard as a dog biscuit. Farmers tended their fields and provided enough food so that no one on the island went hungry. In their workshops, artists carved vases out of stone, and goldsmiths designed the beautiful jewelry the people of Crete liked so much.

The ladies of Crete spent a great deal of time on their appearance. They wore the most elaborate clothes ever seen in the ancient world. Wide, colorful skirts swung out from their tiny waists. They used white face paint and eyeliner, and reddened their lips. Row upon row of beads hung around their necks. Earrings dangled from their ears and rings decorated their fingers. They carried large ostrich feathers as fans and probably wore high-heeled shoes for special occasions.

Although the men covered themselves only with loincloths, they too adorned themselves with jewelry. Often, collars of precious stones and metals circled their necks. They also wore armbands and bracelets on their upper arms and wrists.

It is not certain how the people of Crete worshiped their gods. One of the most important goddesses was certainly the Snake Goddess. Dressed as a fashionable woman, she held a snake in each hand. Possibly, because it sheds its skin and then grows another, the snake was a symbol of rebirth. It is thought that even the poorest families in ancient Crete left a cup of milk and a little bit of food outside their homes for the snakes to enjoy. Wealthy families had special rooms to welcome the snakes.

One of the mysteries of early Crete was the more than 2000 clay tablets that were found on the island. Scratched into the clay were marks that seemed to be an early form of writing. A young Englishman named Michael Ventrus finally broke the code. On most of the tablets were lists of items bought and sold, like store receipts. Archaeologists call this writing Linear B. They are still working to decode an even earlier form of writing, Linear A. Every attempt to read Linear A so far has failed— but scientists have not stopped trying.

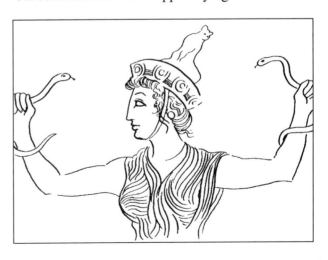

# EXPLORING THE ART

◆◆◆◆◆◆◆◆◆◆◆◆◆◆◆◆◆◆◆◆◆◆◆◆◆◆◆◆◆◆◆◆◆◆◆◆

## *Fresco of Bull Leapers*

**The Palace of Knossos, Crete, Greece**
**Circa 1500 B.C.**

### ◆ First Glance

**What animal is stretched across the center of this fresco?**
The fresco is dominated by a huge, charging bull.

**How many people are in the painting?**
There are three people.

### ◆ Closer Look

**Are the people men or women?**
In Minoan art, men were always painted red and women white. There are two women and one man.

**What do you think they are doing?**
They may be professional athletes trained in the sport of bull leaping. Each stage of the contest is shown on the wall painting: First, the athlete grabbed the horns of the charging bull. Then, he or she performed a death-defying somersault over the bull's back. Finally, the athlete jumped to the ground to land behind the bull.

**Did these contests really take place?**
Other pictures of this athletic event on seals, sculptures, and cups have led historians to conclude that bull leaping was a very popular and widely practiced sport. The details of how it was done remain a mystery. When archaeologists excavated several bull's skulls in Crete, they discovered that the tips of the horns were sawed away—probably to lessen the risk of serious injury.

**Why was such an event so popular?**
Like bullfighting and even the Roman gladiator duels, this sport, which pitted man against beast, thrilled the crowds. The uncertainty of the outcome and the bravery of the athletes added to the sense of excitement. Designs on Minoan seals show that sometimes the performers fell and were trampled by the bull.

**Could this event have been part of a religious observance?**
Minos was often called the Bull King. Legend told that he had a bull as an ancestor and was half bull himself. Earthquakes, a frequent and frightening event in Crete, were thought to be the roaring of an angry bull beneath the earth. And, of course, the Minotaur, the half-man, half-bull in the myth of Theseus, was said to live in the depths of King Minos' palace. The bull was definitely thought to have magical powers and it is possible that bull leaping was more than just a sport. It may have been part of an unknown religious ceremony.

**Where did the games take place?**
They may have taken place in the palace courtyard. People probably watched from behind waist-high barriers.

**Where was the fresco found?**
It was discovered in a room in the Palace of Knossos. The walls of the palace were decorated with many of these brilliantly colored frescoes. Fresco painting was one of the most important

forms of Minoan art. Before the frescoes were uncovered, no one had any idea of what the Minoans of 3500 years ago looked like or how they lived.

### How is a fresco made?

The paint is applied very quickly to a wet, white plaster wall. That way, the colors are absorbed into the wall and do not fade.

### What is moving in the bull-leaping fresco?

Everything from the athletes' arms to the bull's tail is painted as though it were moving. A fanciful border of repeated shapes in several different colors adds a sense of motion to the painting.

### What is the mood of the painting?

The painting expresses a sense of lightheartedness and fun. The bull is not portrayed as a threatening presence—the athletes do not cower in fear. Minoan art seems to celebrate the joy of life. Even this very

dangerous sport was painted in a light and appealing manner.

### Why are the figures of the people so small compared to the bull?

Probably to emphasize the bull's importance in the spiritual life of the Minoans.

### How did the Minoans dress for this event?

Male and female athletes dressed comfortably in loincloths and high boots. The women also wore bracelets.

Minoans were always depicted as young, slender, beautiful, and athletic. The men were painted with broad shoulders. Both men and women were shown as having long, graceful arms and legs and tiny waists. It is thought that at about the age of ten, Minoan children were bound with tight metal belts to ensure that they would have small waists when they grew up.

# Feats of Courage

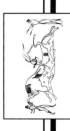

It took great skill and courage for young Minoan athletes to leap over bulls. In the space below, draw a modern-day activity that takes both skill and courage. Color your drawing.

**Name:**

# A-Maze-ing Theseus

This maze represents the rooms in the Palace of Knossos. On the bottom, Princess Ariadne is giving the ball of thread to Theseus. Start by putting your pencil on the thread in Theseus' hand. Lead him into one of the openings of the maze. Before he gets to the Minotaur, he must enter the room of each young man and woman to rescue them. You may have him retrace his steps. Put a check mark ✓ on each of the 13 Greek youths as Theseus passes through. When Theseus reaches the Minotaur, put an **X** on the monster to show that he has been slain.

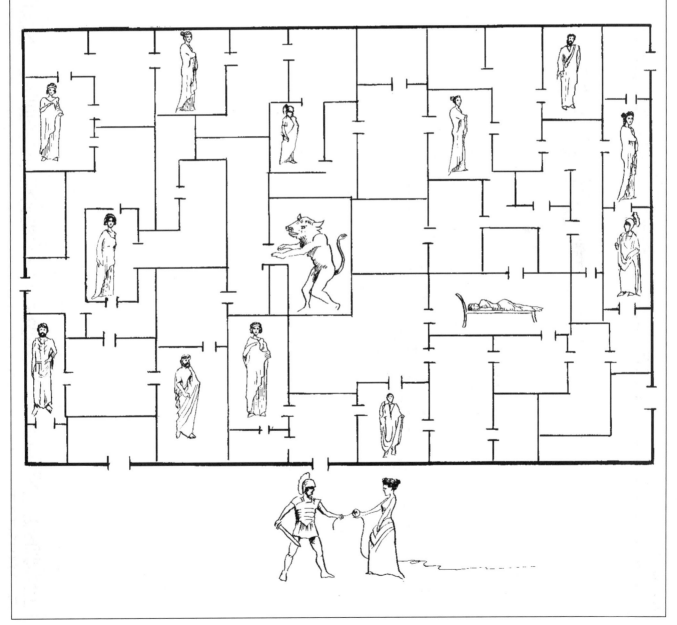

# Our Town

◆◆◆◆◆◆◆◆◆◆◆◆◆◆◆◆◆◆◆◆◆◆◆◆◆◆◆

One fascinating archaeological discovery from Knossos was of a group of small plaques. When put together, they made up a picture of a street in an ancient Minoan town. The houses were two or three stories high with flat roofs and many windows.

Draw the shapes of some of the houses and buildings in your town or city along the line below. You might want to include your home, your school, the post office, the fire department, and a favorite store. Pretend that the picture you are creating will help future archaeologists understand 20th-century architecture.

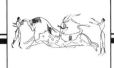

# EXTENSION ACTIVITIES

**1.** Legends tell that a Greek architect and inventor called Daedalus came from the island of Crete. With your class, read the myths about how Daedalus constructed the labyrinth to house the Minotaur and made wax wings for himself and his son, Icarus. Now have students write their own Daedalus myths in which Daedalus creates another extraordinary invention. What might he have invented? How was it used? Students may wish to illustrate their myths.

**2.** Ask students to pretend they are reporters for the *Minoan News*. Have them write a headline and an article describing the bull-leaping event shown in the fresco. Make sure they explain how the athletes were dressed and tell about the reactions of the fans.

**3.** The Minoans traded with many other nations. Minoan objects of art have been found in Egypt, for example. The United States trades with many other nations as well. How many items in your students' homes come from other countries or were influenced by other cultures? What would life be like without international trade?

**4.** It took a long time to decipher Linear B, the ancient Minoan writing. Divide the class into groups. Have each group develop a code and pass a message written in the code to another group to decipher.

**5.** The athletes who participated in bull leaping were physically fit and very well trained. Minoans thought that both men and women should exercise. What rules should be followed to stay fit and healthy in today's world? Invite students to brainstorm a list. Do students think the rules were different in Minoan times?

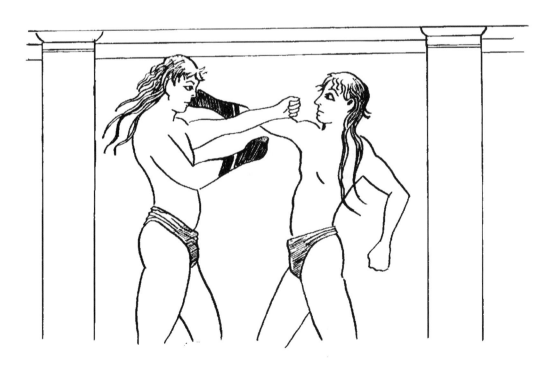

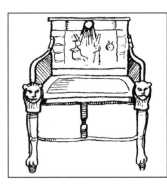

**Egyptian Art**

# DISCOVERY:
## *Royal Throne of King Tutankhamun*

◆◆◆◆◆◆◆◆◆◆◆◆◆◆◆◆◆◆◆◆◆◆◆◆◆◆◆◆◆◆◆◆◆◆◆◆◆◆◆◆◆◆◆◆

**Valley of the Kings, Egypt, circa 1325 B.C.**

In 1334 B.C., a nine-year-old boy named Tutankhamun (too-tan-KAHM-en) became the ruler, or pharaoh (FAYR-oh), of Egypt. It is known that he married 12-year-old Ankesanamun (ank-ah-san-AH-mun) and that he died suddenly when he was only 18. He was buried in a secret underground tomb in the Egyptian desert.

The Egyptians believed in a life after death. They thought that in the afterlife, the king would be reborn. So, everything that Tutankhamun might need in his next life—furniture, jewelry, games, food, clothes, weapons, even boats—was placed in his tomb.

Most important, though, the pharaoh's body had to be made to last forever. First, all the internal organs except the heart were removed. The body was dried out, rubbed with oils and spices, and wrapped in yards of fine linen. Tutankhamun's mummy was placed in the tomb, and the entrance was tightly sealed to keep out robbers. Tutankhamun's family and friends believed that the young king would now begin his journey to the next world.

For over 3000 years the tomb of Tutankhamun was forgotten. Then archaeologists (ar-kee-OL-o-jists) began digging in a desert called the Valley of the Kings, hoping to find a pharaoh's tomb that had never been broken into. But every tomb they discovered had been robbed.

There was one English archaeologist, Howard Carter, who believed that Tutankhamun's tomb was still somewhere in the Valley. A rich man named Lord Carnarvon gave Carter money to begin a search. For years he dug without finding the tomb. Then, in 1922, some workmen found steps that led down to a secret door with Tutankhamun's name on it. The seal on the door had been broken by robbers shortly after Tutankhamun was buried. Fortunately, though, they had taken only a few small objects. Over 2000 splendid artifacts remained in the tomb.

The first room of Tutankhamun's tomb to be explored was the antechamber (ANT-ee-chame-ber). It was here that Tutankhamun's amazing golden throne was found.

Finally Carter entered the burial chamber. A large box covered with gold completely filled the room. Within the large box were three more boxes, each fitting inside the other. Inside the smallest box was a sarcophagus (sar-COF-a-gus), or stone coffin. It contained a nest of three mummy cases. The innermost mummy case was made from 242 pounds of gold. It held the mummy of Tutankhamun. Covering the face and shoulders of the young king was an incredibly beautiful gold mask.

# EXPLORING THE CULTURE

Ancient Egypt was one of the first and most remarkable civilizations in the world. The early Egyptians lived along the banks of the Nile River. Every year the river overflowed and flooded the land on either side. If this had not happened, there would have been only desert.

The Nile was like a busy highway. Boats, rafts, and ferries traveled up and down the river on business. Farmers planted their crops in the rich soil that formed when the river flooded. Egyptians ate the fish that swam in the Nile and the birds that lived in its marshlands. The marshes also provided the Egyptians with a tall reed called papyrus (pah-PY-rus). From this plant, they made a strong but lightweight paper on which they could write.

The Nile made Egypt wealthy and successful. The pharaoh, his nobles, and priests and government officials lived in great luxury. They gave fancy parties with lots of food and drink. Groups of singers, acrobats, jugglers, and musicians amused the guests, who ate with their fingers from beautiful pottery dishes. The guests were given small wax cones filled with perfume to wear on top of their heads. As the wax melted, the sweet scent of perfume filled the air.

Most of the Egyptians were not so wealthy. They were hard-working farmers or laborers who lived in houses made of sun-dried mud bricks. There were also craftsmen and artists who were employed by the pharaoh and his nobles to build and decorate the pyramids, palaces, and temples of ancient Egypt.

Just about every part of Egyptian life was concerned with religion. For centuries, the Egyptians worshiped many, many gods. The pharaohs built temples to honor these gods, but ordinary people were not allowed inside them. If a person wanted to ask a question of one of the gods, a scribe would write it down on a scroll of papyrus. Then the question was given to one of the priests who watched over the temple. Egyptian scribes wrote in hieroglyphics (hi-er-oh-GLIF-iks), an early form of picture writing. Since most people in Egypt could not read or write, the role of the scribe was very important.

When important people died, the Egyptians buried them in tombs in the desert or in the cliffs bordering the Nile valley. The first pharaohs of Egypt were buried in tombs with sloping sides and flat roofs made of mud brick. These were called mastabas (MAS-tah-bahs). Other pharaohs wanted grander tombs. They began building great pyramids (PIR-a-mids), with square bases and triangular sides that met at the top. Near the most famous pyramid at Giza (GHEE-za) sat a huge statue of a lion with a human face called the Sphinx (sfinks). The job of the Sphinx was to guard the pyramid.

But even the Sphinx could not keep the grave robbers away. Since the Egyptians knew that the tombs were filled with fabulous treasures, not one pyramid escaped the thieves. Later pharaohs searched for better hiding places. They went to the western part of the desert and built underground tombs deep down under the rocky cliffs. This part of the desert is now known as the Valley of the Kings.

# EXPLORING THE ART

◆◆◆◆◆◆◆◆◆◆◆◆◆◆◆◆◆◆◆◆◆◆◆◆◆◆◆◆◆◆◆◆◆◆◆◆◆◆◆◆◆

## *Royal Throne of King Tutankhamun*

**Valley of the Kings, Egypt**
**Circa 1325 B.C.**

### ◆ *First Glance*

**Who are the two people pictured on the back of the chair?**
They are the Pharaoh Tutankhamun and his wife Ankesanamun.

**Where do you imagine the scene on the chair back takes place?**
It is probably in one of the rooms of the royal palace.

### ◆ *Closer Look*

**Why do you think the chair is covered with gold?**
This chair was the throne of Tutankhamun, the ruler of Egypt. Egyptian artists carved it from wood and covered the wood with sheets of gold and silver. The back of the chair is inlaid with colored glass and semiprecious stones. The use of such valuable materials reflects the importance of the person who sat in it.

**How many other pieces of furniture can you see?**
Tutankhamun's feet rest on a small footstool. He is sitting on a chair that is similar in design to chairs found in his tomb. To the right of Ankesanamun is a small table.

**How do you think the pharaoh and his wife feel about each other? How can you tell?**
They seem to be looking at each other with affection. Ankesanamun is leaning toward her husband with tenderness.

**Can you find the small blue bowl in Ankesanamun's left hand? What do you think it contains?**
The small blue bowl holds perfumed oil with which Ankesanamun will anoint her husband in a sacred ceremony.

**Unlike most Egyptian art, which appears still and stiff, parts of the scene seem to have movement. What looks as if it is in motion?**
Tutankhamun's arm rests very casually on the back of the chair as though he has just placed it there. Both his neck scarf and the sash around his waist seem to float in the air. Ankesanamun tilts the upper part of her body forward as she reaches out with her graceful hand. Her scarf and and her long, flowing robe also appear to be moving.

**How would you describe the clothing of Tutankhamun and Ankesanamun?**
Their clothes are made out of a fine, thin linen fabric. Since it is extremely hot, they are dressed comfortably. Tutankhamun wears a long, pleated skirt with a sash that ties at the hip. Part of the sash is made to look like an apron in the front. Ankesanamun is wearing a loose-fitting robe over a draped and pleated ankle-length dress.

**What kind of jewelry is the royal couple wearing?**
Around their necks are brightly colored beaded collars. Each row of beads has a different pattern. They are also both wearing bracelets.

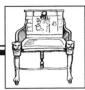

**Can you find a piece of jewelry that is not being worn?**

On the table next to Ankesanamun is another magnificent collar. The artist stood it up so we can see each row of its design.

**Did you notice that both Tutankhamun and Ankesanamun are wearing makeup?**

In ancient Egypt it was fashionable to draw a thick ring around each eye with a brush dipped in kohl, a black makeup similar to eyeliner. The dark eyeliner also helped protect eyes from the glare of the sun. Have you ever seen athletes with black marks under their eyes?

**What are Tutankhamun and Ankesanamun wearing on their heads?**

In that hot climate, men wore their hair very short or even shaved their heads. On important occasions they wore elaborately combed wigs. Women also wore wigs, but had complicated hair styles underneath. In this scene, the king and queen are wearing blue wigs, which symbolize both heaven and royalty.

**What is on top of the wigs?**

Tutankhamun and Ankesanamun are wearing elaborate ceremonial crowns. The golden circles in the crowns represent the sun god, Amon-Ra, one of the most popular gods of the time.

**What is at the end of the large sun's rays?**

The rays nearest to the noses of Tutankhamun and Ankesanamun end in ankhs. The ankh, like a cross but with an oval shape on top, symbolized life. The Egyptians thought that the nose was the passageway through which life entered the body.

**Can you find the king of beasts?**

On the arms of the chair we see the faces of lions. The chair legs end in carvings of lions' paws with painted toenails. The lion has always been a symbol of strength and power. The sphinx, for example, has the head of a pharaoh and the body of a lion.

**Do you see any reptiles?**

Along the top of the chair is a row of cobras with sun discs on their heads. The cobra meant royalty. If you look carefully, you can see more cobras in Tutankhamun's crown.

**Can you spot any hieroglyphics or picture writing?**

There are hieroglyphics within the oval shapes you can see in the gold background. The ovals are called cartouches. Each cartouche contains the name of a pharaoh or Egyptian god. How many can you find on the chair?

**Did you notice that Tutankhamun seems to have two left hands?**

The Egyptians drew things in a special way. If they had painted Tutankhamun with one left and one right hand, we would not be able to see the thumb on his right hand. To an Egyptian artist, it was more "real" to show every finger—even when it was not anatomically correct!

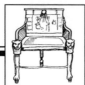

# Sitting Pretty

Pretend you have been anointed king or queen. Design your royal throne. Decorate it with symbols and activities that are important to you.

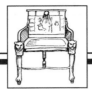

# How to Live Forever

The ancient myth of Osiris (o-SY-res) is told in a wall painting in King Tutankhamun's tomb. Here is the story:

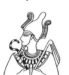 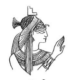 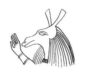  
**Osiris**     **Isis**     **Set**     **Ra**     **Horus**

 was both a god and the first pharaoh of Egypt. His people loved him. He taught them how to plant crops and build great cities.

 was married to the beautiful goddess , but trouble was in store for them.

had a brother, who was an ugly monster. was so jealous of  that he killed him and scattered his body throughout Egypt.

 cried so hard that her  caused the Nile to overflow its banks. She prayed to the god, , for help.

 told to collect all the parts of 's body. Then wrapped  as a mummy and held an ✝, the Egyptian symbol of life, to the mummy's . came back to life as a god of the afterlife.

 and  had a son, the falcon-headed god . battled with his cruel Uncle  and won from him the rule of the world.

According to Egyptian legend, every pharaoh ruled the world as . When the pharaoh died, he joined  and ruled the afterlife.

Now use these same characters to write your own myth on a separate sheet of paper. If you like, you can use some other pictures to tell your story, too.

31

# Create Your Own Cartouche

King Tutankhamun's name was always written inside an oval shape called a cartouche (kar-TOOSH). Write your first name in hieroglyphics inside the cartouche. The symbol for each letter of the alphabet appears on the sides of this page.

A
B
C
CH
D
E
F
G
H
I
J
K
L
M
N

O
P
PH
Q
R
S
SH
T
TH
U
V
W
X
Y
Z

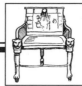

**Egyptian Art**

# EXTENSION ACTIVITIES

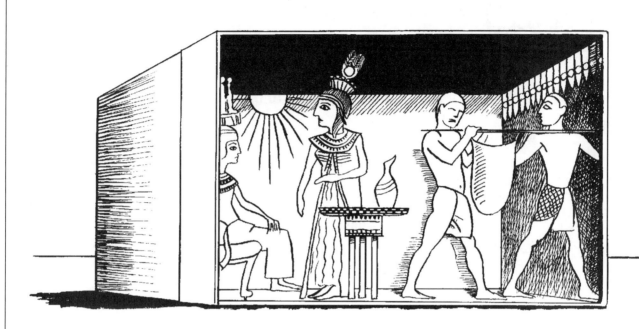

**1.** Of the Seven Wonders of the Ancient World, only the pyramids of Egypt remain. Have your students find out what the others were. Can they make a list of what they might consider to be the Seven Wonders of the Modern World?

**2.** Have students make a diorama of an Egyptian scene. The figures might be wearing wigs, makeup, and the elaborate dress of the nobility.

**3.** The ancient Egyptians had many amulets for good luck. Among them were the hippopotamus and the ankh, the symbol of life. Have students create their own good luck charms by cutting out the shape of a lucky object or animal and decorating it. In addition to crayons or paint, you might provide sequins, glitter, or beads. Students may wish to punch holes in the amulets and wear them around their necks on a string.

**4.** Egyptian measurements were based on the human body. One cubit was equal to the distance from the elbow to the fingertip. Seven hands, each four fingers wide, equaled one cubit. A digit was the width of a finger. Ask your students to measure the widths of the classroom, the blackboard, their desk, and a notebook using cubits, hands, and digits. Have them compare their answers.

**5.** Because King Tutankhamun was buried with his games, food, furniture, chariot, and treasures, archaeologists were able to learn about his life and culture. Invite cooperative groups to brainstorm lists of things they would leave behind in such a tomb, then discuss what those items might communicate about their culture. When everyone is finished, bring the groups together to compare and contrast their lists. Some of the items might be collected and buried in a time capsule on school grounds.

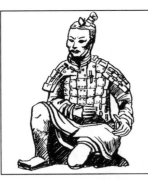

### Chinese Art

# DISCOVERY:
## *Clay Army of the Emperor Qin*

◆◆◆◆◆◆◆◆◆◆◆◆◆◆◆◆◆◆◆◆◆◆◆◆◆◆◆◆◆◆◆◆◆◆◆◆◆◆◆◆

**Xian (shee-en), China, 210 B.C.**

*I*n 1974, some farmers were digging a well in northern China when they discovered an underground pit. Much to the farmers' amazement, there were a number of large clay figures inside. The pit was about a mile away from the tomb of Emperor Qin (chin), a great ruler of ancient China.

The farmers lost no time calling in archaeologists (ar-kee-OL-o-jists) to examine the unusual figures. The archaeologists uncovered three other similar pits in the same area. The pits contained a total of almost 8000 statues of Chinese warriors and horses. The statues made up the underground army of the Emperor Qin.

Pit number one was the largest. The floor was paved with brick. This pit contained mostly foot soldiers, or infantry, some archers and crossbowmen, and chariots and charioteers. Pit number two was filled with cavalry soldiers, who rode horses, and kneeling archers. Pit number three appeared to be the army's headquarters. It contained many officers and their body guards. Mysteriously, the fourth pit was empty. Can you guess why? No one is certain.

All the soldiers stood lined up, ready to march out and help the emperor if he were in trouble. The Emperor Qin was always afraid that his enemies would destroy his kingdom. He believed that the clay warriors would bravely defend him in battle and protect him from danger.

Although the warriors were made of clay, their weapons were metal. Shortly after the Qin dynasty (DI-nes-tee) ended and the Qin family no longer ruled China, robbers looted the pits and stole many of the valuable bronze weapons. But the clay soldiers remained, quietly guarding their emperor for over 2000 years.

Up to now archaeologists have uncovered only the incredible clay army. But they continue to dig. As they make their way to the inner tomb of the Emperor Qin, they may find other pits. No one knows what surprises are still in store.

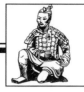

# EXPLORING THE CULTURE

◆◆◆◆◆◆◆◆◆◆◆◆◆◆◆◆◆◆◆◆◆◆◆◆◆◆◆◆◆◆◆◆◆◆◆◆◆◆◆◆

Over 2200 years ago, the country we now call China was made up of many different warring states. A man named Cheng became the ruler of the small state of Qin. With his army of one million soldiers and 1000 chariots, King Cheng conquered all of the other states. The country was united for the first time.

The king decided that he now deserved a more important title. He called himself Qin Shi Huang Ti (chin sur hwong dee), which means the First Supreme Emperor of China.

Although the Qin dynasty lasted for only a short time, the First Emperor changed his country forever. Because China was so large, it was very difficult to manage. Qin decreed that all of China should have the same laws. Everyone in the kingdom had to use the the same money—a round copper coin with a square hole in the middle. All people had to write the same way, so a person living in the south of China could communicate with a person in the north. Weights and measures throughout the kingdom had to be the same. Even the color of a person's clothes was determined by the emperor: everyone had to wear black.

Qin did many good things for China, but he was also a ruthless and feared ruler. He burned the country's books and killed scholars who disagreed with him. During his reign, he built the Great Wall of China to keep out Mongolian invaders from the north. It is estimated that some 300,000 workers

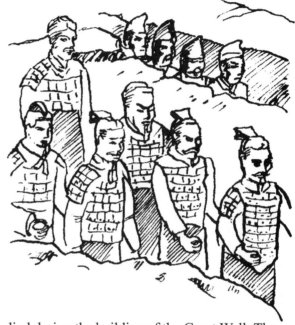

died during the building of the Great Wall. The Chinese called it the Wall of Tears.

Emperor Qin wanted to live forever. So, he put much of his energy into building his tomb, which lies under an enormous mound of earth in northern China. Designed as an underground palace, it took 36 years to build. The ceiling was decorated with precious stones representing the sun, moon, and stars. The floors were a map of the earth. Crossbows were set to kill anyone who dared enter. Qin also ordered many of the men who worked on the tomb to be killed so they could never tell where the entrance to his eternal home was placed.

**Chinese Art**

# EXPLORING THE ART

◆◆◆◆◆◆◆◆◆◆◆◆◆◆◆◆◆◆◆◆◆◆◆◆◆◆◆◆◆◆◆◆◆◆◆◆

## *Clay Army of the Emperor Qin*

**Xian, China**
**210 B.C.**

### ◆ First Glance

**Can you guess the size of these sculptures?**

Most of the figures were slightly larger than life-size. However, very important soldiers were even bigger.

**Do you think there were once Chinese soldiers who looked like these?**

The unknown artists of 2200 years ago who designed these figures probably used real soldiers from the emperor's army as models.

### ◆ Closer Look

**Can you tell what job the soldier in the center had in the Emperor's army?**

The kneeling figure in the center was an archer.

**What would he have been holding in his hand?**

He once held a crossbow. A quiver of arrows may have been strapped to his back.

**Can you tell what job the soldier on the right performed?**

He was a charioteer. This statue is 6 feet 2-1/2 inches tall, which shows the figure's importance. He was probably an officer. Officers often gave commands to the troops while riding a chariot.

**What could he have been holding in his hand?**

His arms are stretched forward in two fists as though he were controlling the reins of the horses pulling the chariot.

**Can you tell what job the soldier on the left performed?**

He was a foot soldier trained in the martial art of shadow boxing, something like karate.

**Which soldiers are wearing armor?**

The charioteer and the archer are wearing armor.

**How is the archer dressed?**

His waist-length suit of armor is made of either small leather or metal squares. They are arranged in overlapping rows and fastened together. The armor protected his chest and shoulders. It was slipped over the head and buttoned on the side. A scarf around the neck of the archer protected it from being irritated by the armor. His hair is arranged in an elaborate topknot.

**How is the charioteer dressed?**

His armored vest is longer in the front. It was similar in design to the protection worn by a baseball catcher. A leather hat is tied under the charioteer's chin. Only the officers in Qin's army wore hats.

**Why doesn't the shadow boxer have armor?**

As a martial artist, he would have to move very quickly and the armor would slow him down. Instead, he wore a padded robe and leggings.

## Were any weapons found?

Although some weapons had been stolen from the pits long ago, archaeologists found more than 10,000 arrowheads, crossbow triggers, and swords. The blades of the swords were still sharp and shiny.

## Why did the Emperor Qin want this huge clay army placed near his tomb?

The Emperor believed in a life after death. It was usual at that time in China for clay figures to be placed in tombs as companions for the dead. Qin wanted a whole army for protection in the afterlife.

## Are the faces of the warriors the same?

If you look closely, you will see that each face is an individual portrait. No two faces in the army are the same.

## How were the figures made?

The artists used both molds and hand carving to make the clay army. The heads, hands, and bodies were separately shaped. Then they were put together and a layer of mud was rubbed over the entire figure. The ears, mustache, and beard were added next and the smaller details carved by hand. Finally, the figures were painted in bright colors. Each army unit had its own colors. Since the army was buried over 2000 years ago, most of the paint has flaked off. But, enough paint remains on some statues to provide clues about what they were once like.

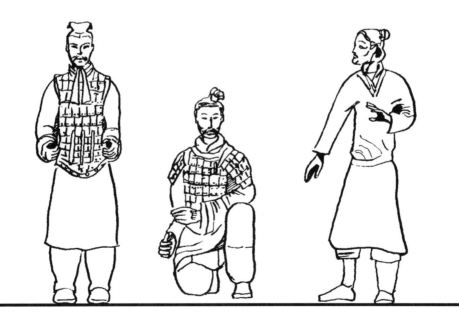

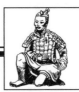

# Qin's Challenge

◆ **Preparation**

1. Reproduce and mount the pages side by side on a large piece of cardboard.

2. Cut out the six DIG! cards. Mix them and stack them face down on the DIG! space in the middle of the game board. If you are playing with friends, add their DIG! cards to the pile.

3. Each player pretends to be an archaeologist and places a colored button or marker on the START square.

4. Each player rolls the die. Highest number goes first, followed by players to the left.

◆ **The Play**

1. The first player rolls the die and moves the button an appropriate number of spaces.

2. The player follows the directions that appear in the space he or she lands on.

3. If the player lands on a DIG! space, he or she should take the top DIG! card and follow the directions. Then replace the card at the bottom of the pile.

4. The object of the game is the be the first archaeologist to reach the underground palace of the Emperor Qin. Good luck!

An amazing find! Your discovery of a tortoise shell with markings may be one of the first examples of Chinese writing.
Advance 2 spaces.

You figure out that the Emperor was called the "Tiger of Qin."
Advance 1 space.

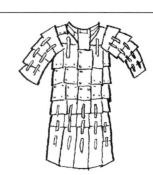

Your shovel has just struck a warrior's armor. Go again.

Your hard work has paid off! You have discovered a beautiful artifact in the shape of an elephant. It may have been used to serve tea. Advance 1 space.

Good work! You have just found ancient money.
Advance 1 space.

Congratulations! You have uncovered a rare jade bird. It belonged to the lady commander Fu Hao.
Advance 2 spaces.

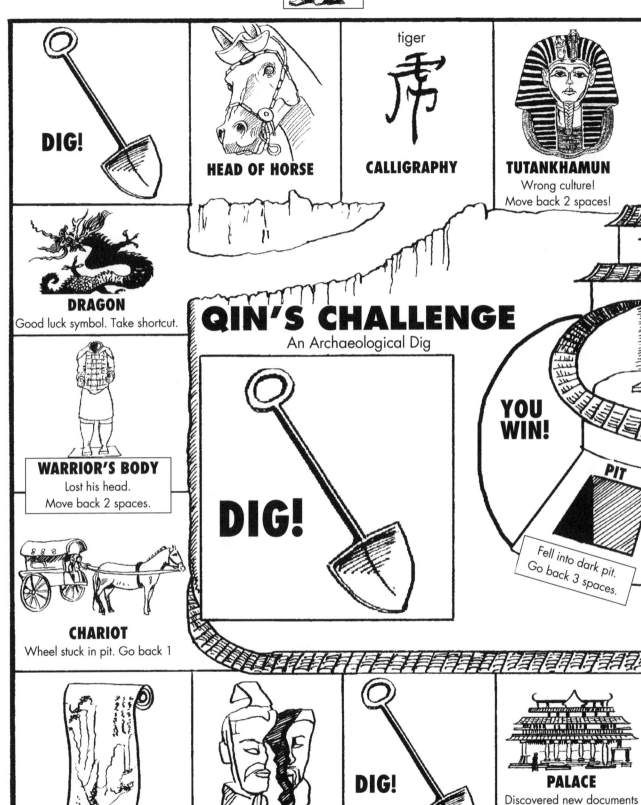

**DIG!**

**HEAD OF HORSE**

tiger

**CALLIGRAPHY**

**TUTANKHAMUN**
Wrong culture!
Move back 2 spaces!

**DRAGON**
Good luck symbol. Take shortcut.

# QIN'S CHALLENGE
An Archaeological Dig

**DIG!**

**YOU WIN!**

**PIT**
Fell into dark pit.
Go back 3 spaces.

**WARRIOR'S BODY**
Lost his head.
Move back 2 spaces.

**CHARIOT**
Wheel stuck in pit. Go back 1

**ANCIENT SCROLL**

**SOLDIER'S HEAD**
Broken artifact.
Lose next turn.

**DIG!**

**PALACE**
Discovered new documents
that describe Qin's palace.
Advance 3 spaces.

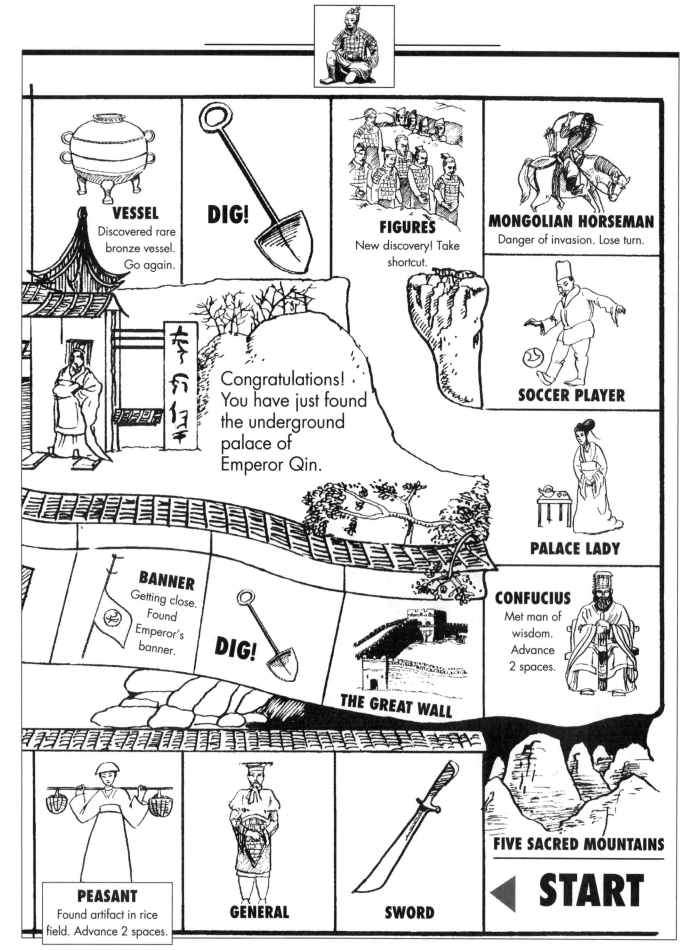

VESSEL
Discovered rare bronze vessel. Go again.

DIG!

FIGURES
New discovery! Take shortcut.

MONGOLIAN HORSEMAN
Danger of invasion. Lose turn.

SOCCER PLAYER

Congratulations! You have just found the underground palace of Emperor Qin.

PALACE LADY

BANNER
Getting close. Found Emperor's banner.

DIG!

THE GREAT WALL

CONFUCIUS
Met man of wisdom. Advance 2 spaces.

PEASANT
Found artifact in rice field. Advance 2 spaces.

GENERAL

SWORD

FIVE SACRED MOUNTAINS

◀ START

**Chinese Art**

# EXTENSION ACTIVITIES

◆◆◆◆◆◆◆◆◆◆◆◆◆◆◆◆◆◆◆◆◆◆◆◆◆◆◆◆◆◆◆◆◆◆◆◆◆◆◆

**1.** The Great Wall of China built by the Emperor Qin still stands and is almost 3000 miles long. To get an idea of just how long the Great Wall is, have students find out the distance between New York and San Francisco. How many days would it take to walk from one end of the wall to the other?

**2.** Traditional Chinese culture greatly reveres old age. The Chinese believe that as people become older, they grow wiser. Consequently, Chinese children show great respect for their elders.

Ask the children to think of an older person they know. It may be a relative, friend of the family, or person who lives or works in their town. Have them interview that person to find out what unique abilities or memories he or she has. Students may then write about what makes the person special.

**3.** In ancient times, the Chinese selected people to run the government based upon their scholarship. A Chinese scholar had to know how to read and write over 10,000 Chinese characters and pass examinations to demonstrate an understanding of history. Discuss with students what they think a person should know to be considered a scholar today.

**4.** The Chinese showed their great appreciation for nature on beautiful scrolls. Have the students think of being outdoors in their favorite season of the year. Then, on a strip of paper 4-1/4 inches by 11 inches held either vertically or horizontally, have them draw or paint a scene from nature. They may add a brief poem or some words of description. The scrolls may be rolled up to take home or hung from yarn around the classroom.

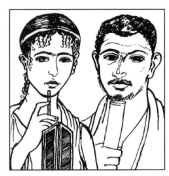

# DISCOVERY: *Double Portrait Wall Painting*

◆◆◆◆◆◆◆◆◆◆◆◆◆◆◆◆◆◆◆◆◆◆◆◆◆◆◆◆◆◆◆◆◆◆◆◆◆◆◆

**Pompeii (pom-PAY), Italy, circa 79 A.D.**

Do you remember the fairy tale of Sleeping Beauty and the magic kingdom? They slept for 100 years before being awakened. The real city of Pompeii slept for 1700 years. It was no fairy tale!

On August 24, 79 A.D., a volcano named Mount Vesuvius (veh-SOO-vee-us) erupted. Red-hot stones and ashes rained down on the Roman city of Pompeii. The sun was covered by a cloud of smoke that rose from the volcano. In the darkness, many people tried to escape. Others stayed and hid in the cellars of their homes; suffocating gases in the cloud choked their mouths and lungs. All this time, the stones and ash continued to fall, blanketing the city. In just a few hours, Pompeii was changed from a rich and vibrant city into a ghost town.

A 17-year-old boy named Pliny (PLIN-ee) the Younger, who lived in another town about 20 miles from Vesuvius, was an eyewitness to the eruption. In a letter to a Roman historian named Tacitus (TAS-it-us), he described his own terrifying experience: "It was the first hour after sunrise, but the light was still faint. The buildings around us were shaking so much they seemed certain to collapse. My mother and I decided to get out of town. The panic-stricken crowds followed us because they did not know what else to do....Once more we were surrounded by darkness and ashes, so thick and heavy. From time to time we had to get up and shake them off for fear of being actually buried and crushed under their weight...."[1] Both Pliny and his mother survived the disaster.

Time passed. Soil formed over the rooftops of Pompeii's beautiful houses and temples. Fields of grass covered the ancient city, and farmers plowed the fertile land. Pompeii slept below, waiting to be awakened.

About 200 years ago, Pompeii was rediscovered. Archaeologists (ar-kee-OL-o-jists) began digging and excavating the ruins. Now one can see this ancient city almost as it was on the day it disappeared.

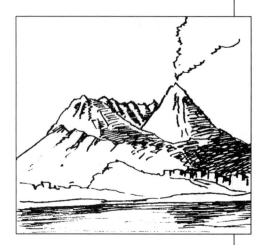

[1]Timothy Levi Biel, *Pompeii* (California: Lucent Books, Inc., 1989).

# EXPLORING THE CULTURE

Where do you like to spend your summer vacations? In ancient times, many wealthy Romans chose to leave their hot city and vacation in Pompeii. There they enjoyed the cool breezes that came off the Bay of Naples and drank wine made from grapes that grew on the slopes of Mount Vesuvius.

Most of all, though, Romans came to Pompeii to be entertained. Vacationers could go to the theater or bet on chariots as they raced around the city. Or they could watch young men train and compete in wrestling, boxing, and discus-throwing at the palaestra (pa-LES-tra), an open-air gymnasium.

Some visitors might choose to browse through the many shops that lined the narrow streets of Pompeii. They might visit the barber, the jeweler, or the button maker, or watch jugglers and musicians entertain in the crowded streets. "Fast food" bars offered quick snacks to busy shoppers.

Afternoons found most men and women at the luxurious public bathhouses. These were not just places for keeping clean, but instead were much like modern health clubs. At the bathhouse, a Pompeian could exercise with weights, sit in a steam room, get a massage, or simply relax and visit with friends.

Without a doubt, the most popular form of entertainment in Pompeii was the gladiator contests. These took place in the huge amphitheater (AMP-feh-theeh-ter), which had the same shape as a modern football stadium. There, thousands of spectators cheered and screamed as they watched gladiators fight to the death.

Like all cities, Pompeii had some problems. Since there was no garbage pickup, people threw their smelly garbage into the street. Pedestrians avoided stepping in the mess by using the high sidewalks or the stepping stones in the middle of the street.

Crime was also a problem in 79 A.D. Most houses in Pompeii had bars on the windows and double locks on the doors. One house even had a mosaic (moh-ZAY-ik) which showed a picture of an attack dog made from bits of stone and glass. Underneath the dog was a warning in Latin that read, "Beware of dog."

And, all over the city, graffiti covered the walls. There were love poems, election slogans, advertisements—even a few complaints by students about their teachers. Life in Pompeii was not so different from life today.

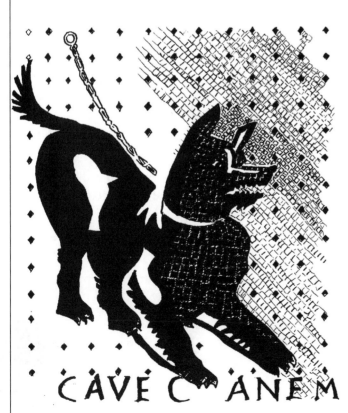

CAVE CANEM

# EXPLORING THE ART

◆◆◆◆◆◆◆◆◆◆◆◆◆◆◆◆◆◆◆◆◆◆◆◆◆◆◆◆◆◆◆◆◆◆◆◆◆◆◆◆◆

## *Double Portrait Wall Painting*

**Pompeii, Italy**
**Circa 79 A.D.**

### ◆ *First Glance*

**Can you guess why this painting is damaged?**

Pompeii was rocked by earthquakes when Vesuvius exploded. Walls cracked and buildings collapsed. It is amazing that something as fragile as a wall painting survived at all.

**Do you think the two people in the painting are related to one another?**

This is a double portrait of a husband and wife. It has been suggested that this was their wedding portrait.

### ◆ *Closer Look*

**What are the man and woman holding?**

The woman holds a wooden tablet that is covered with a thin layer of wax. In her other hand, she has a writing implement called a stylus. The pointed side of the stylus was used to scratch into the surface of the wax. The flat end was used as an eraser to smooth the wax so it could be reused.

The man is holding a scroll with a red seal on the top. The seal shows it is an important document. The scroll is of papyrus, a kind of paper made from the stems of plants.

**In what language did they write?**

They wrote and spoke in Latin.

**Why would they want to be painted holding a tablet and scroll?**

They are proud that they can read and write—though, from the amount of graffiti found all over the walls of Pompeii, it would seem that many people were literate.

**How did Pompeians learn to read and write?**

At the age of seven, most Roman boys and girls went to school, where they were taught to read and write. Girls of 12 or 13 left school and were tutored in their homes. Some wealthy boys went on to study Greek and Latin literature, mathematics, and history. Often the teachers were Greek slaves. These slaves may have been among the most educated people in the city.

**Who were the slaves?**

Almost half the population of Pompeii was slaves. Most slaves were prisoners of war who had been captured as the Roman Empire expanded. Slaves did most of the work in Pompeii. Some were even doctors and artists. It was possible for slaves to gain their freedom. Former slaves were called freedmen.

**Can you guess what the man in the portrait does for a living?**

Some art historians think he is a baker. Others speculate he is a lawyer. Nobody knows for certain. Some think his name is Proculus. Let's call him that.

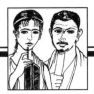

**What would it be like to be a baker in Pompeii?**

A baker might have worked in any one of the 33 bakeries that have been discovered in Pompeii. The bakery probably would have been attached to the house where he lived, and his oven would have looked very much like the ovens you see in a modern pizza parlor. The baker would have baked many kinds of bread and even dog biscuits every morning.

**What would it be like to be a lawyer in Pompeii?**

Lawyers presented their cases in the law courts and government buildings that were grouped around the forum, the main square in the town. Law cases went on for years and years. Friends, and even professional applauders, would come to cheer a well-delivered speech or boo a bad one. Lawyers represented their clients without getting paid. It was considered their duty as good citizens.

**Did Proculus' wife work?**

Her main job was to care for her family. If Proculus was a baker, his wife might have been in charge of running the shop. Then, she may have used the writing tablet she is holding to keep the accounts. If, on the other hand, Proculus was a lawyer, his wife might be holding the stylus and tablet to show she had enough leisure time to write poetry or enjoy literature.

**Do you think this portrait shows the couple the way they really looked?**

Artists working in this time period painted in a very realistic manner. They did not try to please their subjects by making them look better. For example, the artist has painted both Proculus and his wife with ears that stick out. Proculus looks as if he needs a shave.

**Where was this portrait located?**

It was painted directly on the wall of a house in Pompeii. The artist even painted a frame around the couple.

**What kind of clothing is Proculus wearing?**

He is wearing a white garment called a toga, which was made of wool. Only freeborn Roman citizens were allowed to wear togas. It was forbidden for slaves and people from other countries to put them on.

**So, what do we know about Proculus by looking at his clothing?**

We know he was a free citizen of the Roman Empire.

**How is the woman dressed?**

The woman in the portrait is wearing a red, ankle-length shift called a tunic. Over her shoulders is draped a wide red cloak. If you look closely, you will notice her earrings.

It was not unusual for Pompeian women to use curling irons and even hair dye. Proculus' wife might be wearing lipstick, rouge, eyeliner, face powder, and perfume.

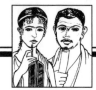

# Two Heads Are Better Than One

A double portrait is a picture of two people. In the frame below, draw a double portrait. It could be you and a member of your family. It could also be your two best friends, or any other couple you wish. Like Pompeian artists, you might want to make your portrait as realistic as possible. The people could hold things in their hands to give us additional information about them.

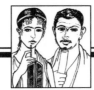

**Name:**

# Then and Now

◆◆◆◆◆◆◆◆◆◆◆◆◆◆◆◆◆◆◆◆◆◆◆◆◆◆◆◆◆◆◆◆◆◆◆◆◆◆◆◆◆◆◆

Daily life in Pompeii in 79 A.D. was not so different from life today. But, of course, some things have changed. In the left-hand column are drawings of life in Pompeii. In the right-hand column, draw how these things look today.

**Transportation**

**Theatre**

**Fast Food**

**Sports**

# The Writing on the Wall

◆◆◆◆◆◆◆◆◆◆◆◆◆◆◆◆◆

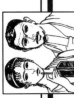

The people of Pompeii loved to write messages. Since papyrus was costly, much of their scribbling was done on the walls of buildings. Some graffiti advertised upcoming events: *Twenty pairs of gladiators...will fight at Pompeii 8-12 April.* There were also words of love: *The weaver, Successus, loves Iris, the slave.* If you were living in Pompeii, what graffiti would you want to write on the walls below? You might announce an event or sell an item such as a toga or chariot.

POMPEii→

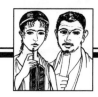

# EXTENSION ACTIVITIES

**1.** The people of Rome explained the shaking of Mount Vesuvius with this myth: Once upon a time there was a battle between the gods and the giants. The gods won and buried the giants while the giants were still alive. To make sure the giants never returned to threaten them, the gods piled a mountain over them. But from time to time, the giants tried to free themselves, causing the mountain to shake and tremble.

Have the students write a myth about a force of nature or a natural occurrence such as thunder and lightning, a blizzard, or an earthquake.

**2.** The Romans spoke Latin. Your students might know some abbreviations of Latin phrases such as P.S.–post script, A.M.–ante meridian, P.M.–post meridian, and etc.–et cetera. Can your students guess what the Latin words mean? Many English words come from Latin, such as auditorium and aqueduct. Can your students find more? Perhaps they can make a Latin root dictionary or create a Roman word wall.

**3.** Invite students to create their own mosaics. First have them make the outline of a simple design, such as a face, animal, or piece of fruit, on a piece of cardboard. Next have them tear or cut up pieces of colored paper, wall paper, or gift wrap. They should

then glue the paper pieces onto the cardboard, using different colors to show different parts of the design, until the entire piece of cardboard is covered.

**4.** Have a toga party. Ask students to wear white t-shirts and bring in old bed sheets. Help the students drape the sheets over their shoulders toga-style and tie a piece of clothesline around their waists. Once they are outfitted, perhaps they can enjoy a Roman banquet of bread, cheese, and grapes. Like the Romans, they may wish to eat with their right hand while reclining on their left side.

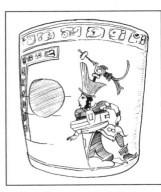

**Maya Art**

# DISCOVERY:
## *Polychrome Vase*
## *of Ball Player*

◆◆◆◆◆◆◆◆◆◆◆◆◆◆◆◆◆◆◆◆◆◆◆◆◆◆◆◆◆◆◆◆◆◆◆◆◆◆◆◆◆

**Yucatan (YOO-ca-tan), Mexico, 600-800 A.D.**

The first Europeans to set eyes on the Maya people were the Spanish explorers and missionaries who followed Christopher Columbus to the New World. About 300 years later, archaeologists (ar-kee-OL-o-jists) began searching for ancient Maya cities in a part of Central America known as Mesoamerica. They wanted to understand the Maya way of life.

Very little had been found out or written about the ancient Maya when an American, John L. Stephens, began exploring Mesoamerica in 1839. Stephens invited his friend, the English artist Frederick Catherwood, to share his adventures. From the moment they arrived in Mesoamerica, they found themselves in difficulty. They ran out of food, got caught in the middle of a civil war, and were both arrested and thrown into jail.

But even these hardships did not discourage the two explorers. After their release from jail, they hacked their way through the jungle, walked in the knee-deep mud of the swamps, and were bitten by clouds of mosquitoes. At times, Stephens wondered whether they would survive.

One day the explorers came upon a stone wall hidden by trees so thick it was hard to see the sun overhead. Then they noticed huge blocks of stone scattered all about. The stones were carved with human figures, masks, and unfamiliar symbols called glyphs (glifs). In the same area were the ruins of a large stone pyramid (PIR-a-mid), a palace, a temple, and other buildings that turned out to be part of the old Maya city of Copan (ko-PAN).

At Copan, the explorers discovered a large ball court decorated with gigantic stone parrot heads. Not far from the ball court was an amazing stone stairway carved with over 2200 glyphs. Catherwood drew sketches of these fantastic objects, and Stephens wrote about them.

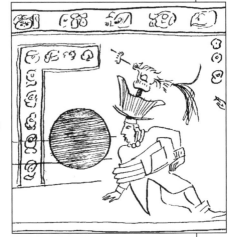

After leaving Copan, Stephens explored other Maya cities. His books, illustrated by Catherwood, became very popular all over the world. They inspired many archaeologists who came after him.

**Maya Art**

# EXPLORING THE CULTURE

◆◆◆◆◆◆◆◆◆◆◆◆◆◆◆◆◆◆◆◆◆◆◆◆◆◆◆◆◆◆◆◆◆◆◆◆◆◆◆◆◆◆◆

Many, many thousands of years ago, Asia and North America were joined by a land bridge. The ancestors of the Maya may have traveled across this bridge from Asia to settle in the New World. As time went on, the Maya civilization spread to Mesoamerica.

Life in an ancient Maya village was based on farming. The main crop was maize (maze), a kind of corn. Because maize was so important to the Maya way of life, it was thought to be a gift from the gods. One legend says that the Maya were created from maize dough.

One of the most important gods was the rain god, Chac, who watered the fields so the maize could grow. When the crops were planted, and again when they were harvested, the Maya prayed to Chac and the other nature gods they worshiped. Sometimes the people offered human sacrifices to the gods. The Maya believed this was one way to repay the gods for a good harvest. They thought human blood made their gods more powerful.

About 2000 years ago, Maya society became divided into rulers and farmers. The rulers began to build great cities with enormous stone palaces, monuments, and steep-sided temples. It was mainly priests and nobles who lived in these cities. Scientists are amazed that the Maya were able to build these great cities with only stone tools and without the help of the wheel.

The Maya recorded their history in a kind of picture writing called glyphs. Because scientists are still working to translate the glyphs, much of the Maya past remains a mystery. It is clear,

though, that the Maya had great mathematical skills. They were one of the few ancient cultures that had the concept of zero, and they developed a calendar of 365 days. The Maya built observatories to study the movements of the stars and planets. With the help of their calendars, Maya astronomers could predict solar eclipses.

The Maya idea of beauty was a person with a flattened forehead and a long face. Shortly after a baby was born, its head was tightly strapped between two wooden boards to shape it. Then a small wax ball was hung in front of the baby's eyes. Mothers hoped this would make their baby cross-eyed. A cross-eyed baby was considered very fortunate and beautiful.

Many Maya filed their front teeth into different patterns and some filled them with precious stones or jade. Even the poorest farmer often wore ornaments through his nose, ears, and lips, and tatooed or painted his body.

About 1000 years ago, the Maya stopped building their temples and monuments and disappeared from their cities. Most moved to the surrounding farms and villages. Once they were gone, the vines and trees of the tropical forests began to grow over and cover the once great cities. What caused the Maya to leave? Was it war or disease or earthquakes or crop failure? No one knows.

Today, the Maya can be found in farming villages in Mexico and Guatemala. Many still speak the Maya language and grow the same crops as their ancestors.

# EXPLORING THE ART

◆◆◆◆◆◆◆◆◆◆◆◆◆◆◆◆◆◆◆◆◆◆◆◆◆◆◆◆◆◆◆◆◆◆◆◆◆

## *Polychrome Vase of Ball Player*

**Yucatan, Mexico**

**600-800 A.D.**

### ◆ *First Glance*

**Can you guess what the man on the vessel is doing?**

He is playing ball.

**What is the large black circle?**

It is the ball.

### ◆ *Closer Look*

**What was this ball game?**

The game played by the Maya was called pok-a-tok. In some ways, it was similar to basketball. There were two teams. The players tried to get the rubber ball through a stone hoop.

**How did it differ from modern basketball?**

Pok-a-tok was more difficult than basketball. The players were not allowed to touch the ball with their hands or feet. It had to be bounced off their hips, chests, shoulders, or wrists. The stone ring or hoop was perpendicular to the ground. It stuck out from the wall like a big lifesaver just above the players' heads. The hoop was only a little bigger than the ball. It must have been quite difficult to score!

**Where was the game played?**

It was played on a ball court about the size of a modern basketball court. The sides of the court had slanted walls. Goals may have been scored by hitting the ball against the wall and having it rebound into the ring. Fans could view the action from the top of the wall. The game was also played by the king and his noblemen on the stairs of the temple. The king always won.

**Where was this game popular?**

The game was played in Mesoamerica as well as the American Southwest.

**What was the ball like?**

It was somewhat larger than a modern basketball and, since it was solid, very much heavier. It weighed about eight pounds and could be as much as 18 inches in diameter. It was made of natural rubber that came from the sap of a tree, and it could bounce very high. Before the Europeans knew about rubber, they used balls made of wood or leather. The rubber ball that was first used in Mesoamerica changed the way sports are played throughout the world.

**How were the winners rewarded?**

No one knows for sure. It is believed that any player who was able to get the ball through the ring could claim the jewelry and clothes of the spectators—if he could catch them.

**What happened to the losers?**

This was not a game a player wanted to lose. The penalty was death. The loser's head was cut off as a sacrifice to the gods.

**Who were these ball players?**

They may have been men captured in war. It is also possible that well-trained athletes and even the nobility participated, hoping for fame.

## How did a ball player dress?

Since the ball was so heavy, a player had to wear protective equipment. Heavy padding covered one knee, foot, and wrist. A bulky belt or yoke was strapped around the waist for added protection. It was probably made of either wood or wicker. The player's body was painted black, a warrior's color. Can you find the ear plugs in the ball player's ears and the necklace around his throat? The player also wore a fantastic feathered headdress.

## Why do you think this game was played?

It was both an athletic event and a religious ceremony. According to the Maya religion, there were two brothers, both excellent ball players, who were destroyed by the jealous lords of the underworld. But one brother left behind twin sons, who became the finest ball players in the world. The Lords of the Underworld challenged the Hero Twins to a contest. The evil gods tried to win by trickery. Day after day the game continued, but the score remained tied. Finally, the Hero Twins outsmarted the Lords and won. They floated up to the heavens, where they became the sun and the full moon. The ball game between the Hero Twins and the Lords of the Underworld is related to the ball games of the Maya. It is possible that the Maya felt that each game was a contest between good and evil.

## On what is this scene painted?

It is painted on a ceramic vase, which was placed in the grave of the ball player when he died.

## Do you see the glyphs painted along the rim of the vase? Why are they there?

It is not certain what the glyphs mean. They might contain the name of a ruler. They might also be part of a hymn for the dead athlete.

## Do you see a bird?

The headdress may be in the shape of a hummingbird, which was sacred to the Maya.

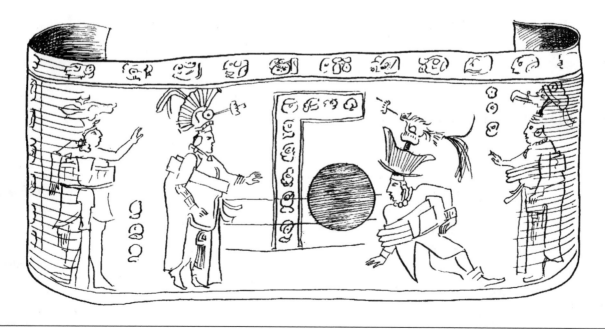

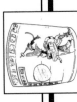

# Play Ball!

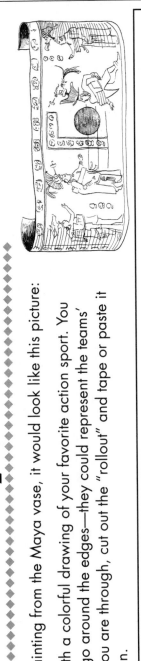

If you were able to unroll the painting from the Maya vase, it would look like this picture:

Decorate the "rollout" below with a colorful drawing of your favorite action sport. You might want to create glyphs to go around the edges—they could represent the teams' insignias, for example. When you are through, cut out the "rollout" and tape or paste it around a standard-size soup can.

# Great Glyphs

The Maya people wrote in pictures and symbols called glyphs. First decode the beginning of the story below. Then, use the glyphs on this page to complete the tale. You may make up your own glyphs or put in words where they are needed.

The _____ planted _____ _____ . But, there was _____ _____

for _____ years. So . . . _____

_____

_____

_____

| zero | one | two | three | four | five | six | seven | eight | nine | ten |
|------|-----|-----|-------|------|------|-----|-------|-------|------|-----|

| storm | rain | fire | tree | building | deer | jaguar |
|-------|------|------|------|----------|------|--------|

| turtle | rodent | monkey | earth | corn god | corn seed | ear of corn |
|--------|--------|--------|-------|----------|-----------|-------------|

**55**

# Heads Up!

The Maya wore very elaborate and heavy headdresses. They were made with wooden frames and tied under the chin. The frames were hung with feathers, jewels, fabric, reeds, and shells. Often the headdresses were more than two feet tall. Parts of them resembled animals or fish. Design and color your own headdress on the head below. See how many animals you can include in it.

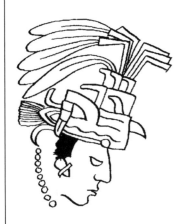

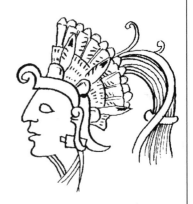

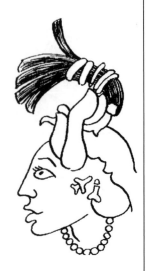

**Maya Art**

# EXTENSION ACTIVITIES

◆◆◆◆◆◆◆◆◆◆◆◆◆◆◆◆◆◆◆◆◆◆◆◆◆◆◆◆◆◆◆◆◆◆◆◆◆

**1.** There were great rivalries and competitions in ancient days between the ball teams of Maya cities such as Tikal, Copan, Uxmal, and Chichen-Itza. Have students pretend they are sports announcers in 700 A.D. Ask them to describe a ball game between the Tikal Tigers and Copan Crocodiles.

**2.** Archaeologists are still uncovering new and mysterious Maya cities. See if your students can locate on a map the sites of Bonampak, Tikal, Copan, Chichen-Itza, Uxmal, Palenque, and Altun Ha. In what modern countries are they found?

**3.** The architecture of the Maya was extremely complex and advanced. Their step pyramids, temples, ball courts, and palaces were built around plazas or squares that were sometimes connected by broad causeways.

Research the layout of a Mayan city. Then have your students design a city of the future. Their plan might include government buildings, a sports arena, a school, a library, and a museum.

**4.** The Maya created a variety of calendars which tracked the sun, moon, and planets. They had a 365-day calendar divided into 18 periods of 20 days each. It also had five unlucky days at the end of the year which they did not name. Another calendar they created was a 260-day calendar, with 13 days in each of 20 months. This calendar was used to identify good and bad days and to predict the future.

Divide your students into groups to create their own calendars. How long should each week be? How many weeks in each month? Ask the students to name their new months. Then have them chart one or two of them. Which days should be holidays? Which should be school days?

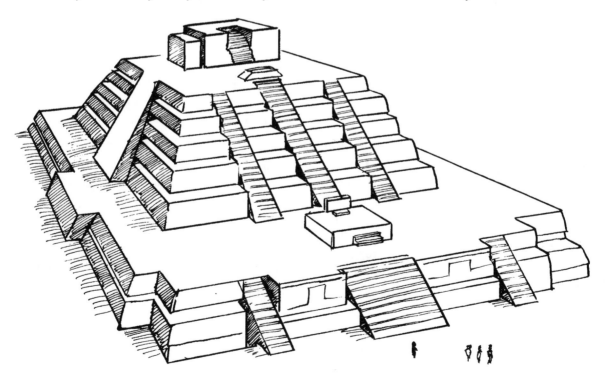

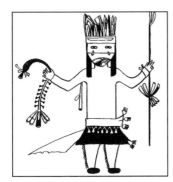

**Pueblo Art**

# DISCOVERY:
## *Wall Painting with Lightning Man*

◆◆◆◆◆◆◆◆◆◆◆◆◆◆◆◆◆◆◆◆◆◆◆◆◆◆◆◆◆◆◆◆◆◆◆◆◆◆◆◆

**Kuaua Kiva (KWA-wah KEE-va), New Mexico, U.S.A., circa 1200 A.D.**

About 450 years ago, Spanish explorers had already conquered most of Mexico. Then the Spanish began to hear tales of people in lands to the north who lived in many-storied clay houses. The Spanish conquerors eventually invaded these lands. They kept written records of their journeys. Later, the records were of great interest to archaeologists (ar-kee-OL-o-jists) searching for clues about the ancient cultures of the southwestern United States.

In 1934, archaeologists began to look for a special ceremonial room with painted walls that had been described by the Spanish in their journals. The ceremonial room was called a kiva. The scientists started excavating a ruined pueblo (PWEB-loh), or village, in what is now New Mexico. The pueblo of Kuaua was built by the Mogollon (MUGGY-own) and Anasazi (An-a-SAH-zee) peoples, who had lived and farmed alongside each other in peace.

At the Kuaua site, archaeologists were able to uncover about 1200 rooms and the skeletons of 600 of the pueblo's inhabitants. They found pottery, stone tools, baskets, corn, and even some seeds that had been used for planting. But the archaeologists still couldn't locate the special painted room they had hoped to find.

One day, an archaeologist was examining a shovelful of dirt that had been thrown into a wheelbarrow. He noticed that there were little pieces of colored plaster mixed in with the dirt. Could the colored plaster have come from one of the nearby walls?

Working carefully, the scientists removed the top layer of plaster from a wall. As they did, they saw the fingers of a hand begin to appear from underneath. When they flaked off more plaster, they discovered that the hand was part of a masked figure outlined in black paint. After further excavation, the archaeologists realized that they were in the sacred meeting place they had been looking for! The walls of the kiva had been replastered more than 80 times. Seventeen of the layers contained colored murals, all of which told stories of religious ceremonies and beliefs.

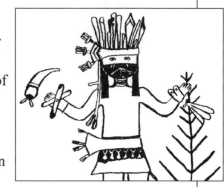

Experts were called in to study and remove the paintings. Today, a reproduction of the painted kiva at Kuaua can be seen at the Coronado State Monument in New Mexico.

# EXPLORING THE CULTURE

◆◆◆◆◆◆◆◆◆◆◆◆◆◆◆◆◆◆◆◆◆◆◆◆◆◆◆◆◆◆◆◆◆◆◆◆◆◆◆◆◆◆◆◆

The first humans to set foot on the American continent were Stone Age hunters. They wandered across a land bridge that once connected Asia to Alaska in search of food. These people slowly migrated down into the region now called the American southwest.

As centuries passed, more people moved into the area. The weather became hotter and drier, and meat became harder to find. The hunters had to gather wild plants, berries, and nuts in order to survive. Then, they learned that they could grow their own food. This discovery changed their way of life forever. The hunter-gatherers became farmers. Since they needed to take care of their crops, they had to settle down in one place, and permanent villages were established.

One of the earliest settlements was that of the Mogollon people, who made their home in the mountains along what is now the border between New Mexico and Arizona. They lived in houses that were mostly underground, much like modern basements. Usually, one of these pit houses was made deeper and larger than the others. This was the kiva, which was the center of Mogollon religious life. Here, young boys learned the ancient songs, dances, and prayers of their people.

The only entrance to the kiva was through a hole in the roof. A ladder led from this opening down to the floor. If the men in the kiva were discussing important matters, they would pull in the ladder so no one could disturb them.

The Mogollon people elected leaders, but they never built palaces or temples in their honor. It is possible that no one owned land because the Mogollon probably believed that the earth belonged to everyone.

Several hundred years later, the Anasazi came to live in the same region. They settled in what is now called the Four Corners, where the states of New Mexico, Arizona, Utah, and Colorado meet. There, on top of the high, flat-topped land formations called mesas (MAY-suz), the Anasazi wove baskets, made pottery, and built their underground homes.

About 1000 years ago, the Anasazi began building a different kind of dwelling. These newer homes were constructed above ground from stone and adobe (a-DOE-bee), a brick made of sun-dried clay. Some were four or five stories high and had hundreds of families living in them. Ladders connected one story to the next. As with the kivas, the entrances were usually through openings in the roofs. Today we call these buildings pueblos.

Then, a little over 700 years ago, almost no rain fell in the area for a period of 22 years. The Anasazi and Mogollon could not grow their crops. Gradually, they left their pueblos, looking for a better life elsewhere.

The Anasazi and the Mogollon never returned to their former homes. Instead, they joined other pueblo dwellers and built new villages. They shared their religion, language, and arts and crafts with their new neighbors. The Zuni (ZOO-nee) and Hopi (HO-pee) peoples are some of their modern-day descendants. Together, these pueblo-dwelling cultures make up what are called the Pueblo people.

# EXPLORING THE ART

◆▪◆▪◆▪◆▪◆▪◆▪◆▪◆▪◆▪◆▪◆▪◆▪◆▪◆▪◆▪◆▪◆▪◆▪◆

## *Wall Painting with Lightning Man*

**Kuaua Kiva, New Mexico, U.S.A.**
**Circa 1200 A.D.**

### ◆ *First Glance*

**How many people can you find?**

The one large figure is the chief of the lightning makers. His name is Kupishtaya.

**How many birds can you find?**

There are two birds, an eagle and a goose.

**How many fish do you see?**

There is one fish, possibly a catfish.

### ◆ *Closer look*

**Why do you think this painting was done in a kiva, a sacred place?**

Like all kiva art, the painting had a religious purpose. It was like a painted prayer.

**Can you guess what the people were praying for?**

The people of the Kuaua pueblo would be able to survive only if there was enough rain and the crops grew. Every object depicted on the kiva wall is associated with rain, good weather, and good fortune.

**What symbols do you notice on Kupishtaya's face?**

Below each eye are tiny white feathers with black tips that represent tears. They probably stood for the rain that the Pueblo people prayed for.

**Why is Kupishtaya so important?**

Kupishtaya is one of the Pueblo nature gods who controlled the universe. He had great power. If the land dried out or the rivers flooded, it was because the people had not behaved correctly toward him or other gods. Therefore, he was painted with great respect. Kupishtaya is also important because he is a kachina figure.

**What is a kachina?**

A kachina is a powerful spirit. The Pueblo people believe that a long time ago, kachinas lived with the people on earth. They would chase away sadness by singing, dancing, and bringing presents. But one day, the people argued with the kachinas and the kachinas left. They went to live in the spirit world, where they remained for six months. Then they returned to earth and entered the bodies of men who wore kachina masks and costumes. These men now felt themselves to be kachinas with all the powers of these supernatural beings.

**What is the role of kachinas in the Pueblo religion?**

The kachinas are honored in many ceremonies because it is up to them to provide abundant harvests and bring prosperity to the people. The kachinas were thought to control every aspect of life. It is possible that this mural was painted to commemorate a kachina festival.

**How does Kupishtaya's clothing show his power over the universe?**

He wears a mask and a black short skirt or kilt with a red border. The black of the kilt represents the fertile earth. The white sash which holds the kilt in place may symbolize the clouds. The hanging tassels are probably the falling rain.

**Can you find all the feathers on the figure of Kupishtaya?**

Kupishtaya's headdress is made of standing eagle and hawk feathers. Under his armpit hangs a feather on a string. From his wrist dangles a beautiful feathered ornament on a white cord. One hand holds a black staff decorated with feathers. And, there are the feathers under his eyes.

**Why are there so many feathers?**

The feathers represented birds, which were sacred in Pueblo culture. Birds were thought to be the children of the sky father and the earth mother. The feathers gave magic power to anyone who wore them. The Pueblo people decorated headdresses, clothing, and arrows with them.

**Let's look again at the birds in the mural. What might be the significance of the large black and white eagle?**

The eagle was admired for its courage and swiftness. Eagle feathers were awarded to the bravest among the Pueblos. The eagle was thought to have the power to ward off evil and, in Pueblo art, often represents a messenger bringing rain from heaven.

**Can you guess what things are coming out of the eagle's mouth?**

(1) Streaming from the eagle's beak are many red, white, yellow, and black dots—these are different kinds of seeds. (2) From these dots flow smaller black dots, which represent drops of moisture or rain. (3) Above the rain dots is a criss-crossed yellow and red lightning symbol that shoots out of the eagle's beak. (4) A red rainbow arcs from the mouth of the eagle to the mouth of the catfish.

**What other rain and water symbols can you find?**

Directly under the eagle's wing is a large black lightning arrow. It sits in a black water jar with a pointed base. The black dots that flow down from the sides of the jar are moisture drops flowing into the earth.

Another yellow lightning symbol zigzags out of the mouth of a fish. The fish, which lives in water, was connected to rain and well-being.

Beneath the eagle's beak is a bat. An arrow shot into the sky could send a message to the gods that rain was needed. Shaped like an arrowhead, the bat was also associated with rainmaking.

**Did you notice the black bottom border painted just above the floor of the kiva?**

The black band represents the fertile earth. All the moisture and seed dots flow toward the band.

**How many layers of the kiva wall had to be removed to get to this particular painting?**

This painting was found on the 26th layer of plaster and was part of a much larger mural which covered three walls. It was the best preserved of all the paintings that were discovered.

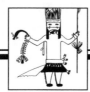

# Create Your Own Kachina

Pueblo children are given wooden dolls dressed like kachinas. The kachina figures are not toys. They teach the children about their religion.

There are hundreds of kachina spirits. Kupishtaya (koo-pish-TIE-uh) the Lightning Man is a very powerful kachina. Some other kachinas are Mud Head, Butterfly Girl, Great Horned Owl, Morning Singer, and Snake Dancer.

Draw and color your own kachina in the space below. It can represent the weather, a season, an animal, or any other aspect of nature. You may want to decorate your drawing with feathers, buttons, or colored paper. Make sure to give your kachina a name. When you are finished, you might want to write a story about it.

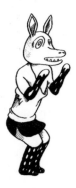

# Tell Me a Story

The kiva wall painting tells a story of a religious ceremony. Storytelling is one way to keep the traditions of the Pueblos and other cultures alive.

Many modern potters make clay figures of Pueblo storytellers. Tiny children are placed in the storyteller's lap. Each child has a different expression. Some smile and others frown. Some are listening and others fall asleep.

Starting with the outline below, draw and color your own storyteller. It could be someone in your family, a teacher, or a special friend—anyone who has told you a good story. Draw some children in the storyteller's lap. Make sure that you are one of the listening children.

# The Magic of the Mimbres

◆◆◆◆◆◆◆◆◆◆◆◆◆◆◆◆◆◆◆◆◆◆◆◆◆◆◆◆◆◆◆◆◆◆◆◆◆

The Mogollon people were very skilled at arts and crafts. They were among the first Native American people of the southwestern United States to make pottery.

When a person died, a piece of pottery called a mimbres (MIM-bris) bowl was brought to the grave. Mimbres bowls were painted black and white. The designs on them were often of animals very much like the birds and fish in the kiva wall painting. It was thought that these special bowls contained the spirit of the person who once owned them. So, before the bowl was buried, it was hit hard to make a hole in the center. This allowed the spirit to escape.

In the circle below, design your own mimbres bowl, using a pencil or black crayon. When you are through, you can cut out your bowl and punch a hole in the middle.

**Pueblo Art**

# EXTENSION ACTIVITIES

**1.** Collect toilet paper and paper towel rolls. Have children use them to make three-dimensional kachina dolls. In addition to colored paper and glue, you might wish to supply leather, beads, fur, and feathers. Have students name their dolls and explain the significance of the particular spirit they have chosen to represent.

**2.** Find out more about how pueblos were built. Then, using cereal boxes, shoe boxes, and milk cartons, have students construct a pueblo. Make sure it includes ladders and a kiva. Encourage students to add small figures to their pueblo, who might be grinding corn, listening to stories, or participating in a ceremony.

**3.** The Pueblo created exquisite pottery from clay. Have students shape small pots from clay. When they are completely dry, they can be decorated with Pueblo-inspired designs.

**4.** Have your students research the Hopi and Zuni tribes. Ask them to find out where and how they live, and what their major concerns are. How are the ancient traditions and crafts reflected in Hopi and Zuni life today?

**5.** Invite your students to research Pueblo life, then pretend they are Pueblo Indians living long ago. Have students write a letter to a friend that tells about their day. Encourage them to include authentic details regarding food, chores, and games.

**Benin Art**

# DISCOVERY:
## *Bronze Plaque of Mounted King and Attendants*

◆◆◆◆◆◆◆◆◆◆◆◆◆◆◆◆◆◆◆◆◆◆◆◆◆◆◆◆◆◆◆◆◆◆◆

### Court of Benin (beh-NEEN), Nigeria, 1550-1680 A.D.

Several years before Columbus discovered America, a small group of Portuguese (por-choo-GHEEZ) trading ships docked on the bank of the Benin River in western Africa. They were greeted by representatives of the Oba (oh-ba), the powerful ruler of the Benin kingdom, and permitted to land. The Portuguese were the first Europeans to visit Benin. They were very impressed by what they saw there. As a result of the visit, the Oba and the Portuguese agreed to trade with one another. The Portuguese sent the Oba guns, mirrors, glass beads, brass, and copper. The Oba provided ivory, pepper, cotton cloth, and slaves. This relationship went on for many years. Ships of other nations began to dock on the Benin River. Benin grew rich and powerful.

Centuries passed. Then, in 1897, a representative of the British government sent a message to the Oba. The British told the Oba when they would arrive at his palace. But the Oba asked them not to come on that date because an important religious ceremony was to take place. The Englishmen ignored the warning and set out anyway. On the road to Benin, they were attacked by the Oba's warriors. Only two of the English survived.

The British navy was ordered to sail to Africa to punish the Oba. The Oba sacrificed hundreds of people to the gods, hoping this would save his kingdom. But Benin was doomed. The Oba was removed from power and at least 2000 art treasures were taken by the British. These treasures are now in museums all over the world. People everywhere have come to love and admire the beautiful Benin art.

Today the kingdom of Benin is part of the modern state of Nigeria. There is still an Oba, but he is no longer the powerful ruler he once was.

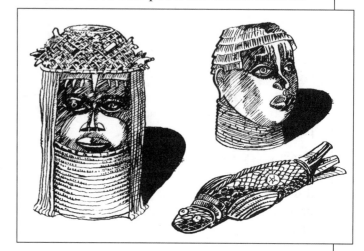

# EXPLORING THE CULTURE

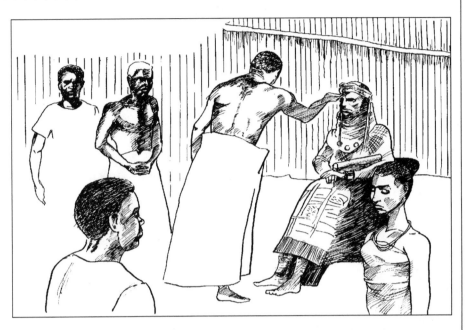

The old kingdom of Benin was located in a tropical rainforest in western Africa. For more than 500 years, this kingdom was ruled by a powerful Oba. The Oba was thought to have magical powers. His people believed he was not an ordinary human being. They thought he never died—he just went on to another place. If the Oba were healthy and happy, then the crops would grow and the armies would win battles. Therefore, every person in the kingdom had to obey the Oba and make sure he was always content.

The Oba lived in a huge mud palace with pointed towers and slanting grass roofs. A wide boulevard led from the forest to the palace. While the Oba lived in luxury, ordinary people lived in villages in the midst of dense forests. Behind their mud huts, farmers grew crops of yams, plantains (PLAN-tens) (a kind of banana), peppers, squash, and pumpkins. On market days, men and women carrying heavy trays of vegetables on their heads could be seen traveling the many narrow paths that criss-crossed the forest. In addition to the farmers, there were the bronze workers and ivory carvers who provided the art that decorated the Oba's palace. These artists worked only for the Oba.

Benin was a warrior kingdom. During the dry season when the crops had already been harvested, drums would echo through the forest spreading the news that it was time to prepare for war. Young men would arrive from all over the kingdom, led by warrior chiefs. Each soldier carried a large shield, spear, sword, bow, and arrows. Led by the Oba, they marched off to battle. It was by war that the Oba was able to expand his mighty empire.

The Oba left the palace only to make war or participate in religious ceremonies. The most important ceremony took place each year when the people honored the Oba by worshiping his head. The entire kingdom would take part in this celebration.

First came the live leopards, chained at the neck. They were followed by musicians blowing ivory trumpets, beating drums, and ringing bells. Then came the Oba himself, wearing many strands of red coral beads. The beads, a symbol of royalty, hung from his forehead, circled his neck, and decorated his crown. Behind the Oba came the women and many, many soldiers armed with spears and swords. The people saluted the Oba and danced in his honor. The Oba was well. They could look forward to another good year.

**Benin Art**

# EXPLORING THE ART

◆◆◆◆◆◆◆◆◆◆◆◆◆◆◆◆◆◆◆◆◆◆◆◆◆◆◆◆◆◆◆◆◆◆

## *Bronze Plaque of Mounted King and Attendants*

**Court of Benin, Nigeria**
**1550-1680 A.D.**

### ◆ First Glance

**Can you find the Oba?**

He is in the center of the plaque.

**How many people do you see on the plaque?**

There are seven full figures. If you look closely, you can see part of another small figure behind the Oba's feet.

### ◆ Closer look

**Can you guess why the figures are so different in size?**

The size and placement of the figures show their relative importance.

**What is the Oba riding?**

He is riding a horse. Horses did not survive very long in the rainforest. Most died of disease, so only the wealthy could afford them. Having a horse added to the prestige of the Oba.

**Can you guess the job that the two small men on either side of the Oba perform?**

By their size, you can tell they are low-ranking members of the kingdom. The figure on the Oba's left carries a sword. These men were probably there to protect the Oba and help support him on his horse. The Oba sits sidesaddle and is not holding onto the horse's reins. Instead, he balances by grasping the hands of the two men.

**Can you guess why the sword-bearing figure on the Oba's right is not wearing any clothes?**

Since the Oba had absolute power over the people he ruled, it was up to him to decide whether or not a person deserved to wear clothes. It is possible that this figure had not yet earned this right. What someone wore determined that person's place in society. If a man gained the Oba's favor, he would be granted the gift of clothing.

**What is the job of the two larger figures on either side of the Oba?**

They both hold their decorated shields over the Oba's head to protect him from the sun. They are next in size to the Oba, which suggests that this job was an honored one and reserved for men of high rank.

**Can you spot the symbol running lengthwise down the center of the shields? What is it?**

The shields carry the symbol of the mudfish, which was sacred to the Oba.

**What was the significance of the mudfish?**

Like the mudfish, which could inflict a powerful electric shock, the Oba could inflict pain on his enemies. The mudfish also had the ability to live for long periods on land as well as in the water. The Oba was thought to be the master of both land and sea. Can you find the face of the mudfish at the hips of the two large attendants?

**Who are the two small figures on the top of the plaque?**

They might be soldier-musicians who accompanied the Oba on his rare visits outside the palace.

**What do we know about the small figure behind the Oba's feet?**

His tiny size and placement seem to indicate that he is the least important person on the plaque. He, too, may be a musician. Or he might be there to lead the Oba's horse.

**How does the Oba's dress differ from that of the other figures?**

A collar of coral beads, the symbol of royalty, completely covers his neck and chin. Coral beads decorate his chest and ankles. Many metal bracelets circle his arms.

**Did you notice that the heads are out of proportion to the size of the bodies?**

In the Benin culture, a person's head was considered the most important part of the body. The Oba's head was considered sacred. Therefore, artists paid less attention to the lower torso and usually made the legs very short. Details of the clothing and jewelry were emphasized to show the individual's social rank. In a way, these details were like the insignias a modern soldier wears to indicate his or her military rank.

**How many patterned surfaces can you find on the plaque?**

The clothing, helmets, and shields are patterned. The background is decorated with four-petaled river leaves. These leaves symbolize the Oba's rule of the sea.

**What was the function of this plaque?**

Since the people of Benin did not have a written language, their history was told in these plaques. They were a pictorial record of royal life in Benin during the 16th and 17th centuries. If there were a question about an event in the past, the plaques could be "read" for information. About 900 of these plaques exist today.

**Where were the plaques hung?**

Groups of plaques were probably hung together on the walls of the Oba's palace. Do you see the nail holes?

**How were the plaques made?**

All the plaques were made by using the lost-wax method of bronze casting. Moist clay is molded around a wax model. The clay is heated, and the wax melts and runs out. Heated bronze is then poured into the empty space where the wax was. This method of casting is still in use today.

# The Oba of the Sea

Ol-okun was a powerful Benin god. He ruled the sea and everything in it. He dressed like a royal person with strands of coral beads and a beaded cap. He held lizards in both hands and his feet were shaped like mudfish. If Ol-okun were happy, the people would have enough fish to eat. If he were angry, he would flood the earth. He lived in an underwater palace and had attendants who were both fish and human.

After rereading the description above, draw Ol-okun in his underwater home. Include his attendants, his palace, and the many sea creatures who surrounded him.

70

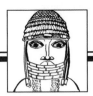

**Name:**

# The Leopard and the Fire

The leopard was sacred to the Oba of Benin. Here is an African myth about the leopard. Create an illustration for each page. Then cut out the pages and staple them together to make a mini-book.

At first, the leopard had no spots. The leopard and the fire were very good friends. Every day the leopard went to visit the fire, but the fire never came to see the leopard.

The leopard's wife thought that the fire was rude. She was very insulted.

The leopard pleaded with the fire not to embarrass him. The fire agreed to meet the leopard's wife if a path of dry leaves were prepared for him.

The fire came roaring along. Although the leopard and his wife escaped, their bodies have been marked with black spots ever since.

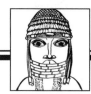

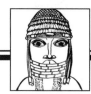

Name:

# Design a Shield

◆◆◆◆◆◆◆◆◆◆◆◆◆◆◆◆◆◆◆◆◆◆◆◆◆◆◆◆◆◆◆◆◆◆◆◆◆◆◆◆◆◆

Some of the Oba's attendants had shields. Benin shields often carried the symbol of a powerful creature in the center. Around the edges of the shield was a decorative pattern.

Draw a powerful symbol of nature in the center of the shield below. Add a pattern around the outside. You may choose a Benin design from those shown below or make up one of your own.

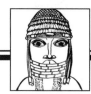

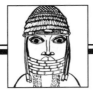

# EXTENSION ACTIVITIES

**1.** Benin artists created beautiful masks of bronze. Artists of other ancient cultures used different materials to make ceremonial masks.

Ask each student to bring in a large paper grocery bag and help them cut eyeholes in the bags. Have students decorate the bags to look like animal heads or with colorful patterns. They may want to add colored paper, yarn, shells, feathers, and beads to their creations. Decide on a good reason to celebrate and have them wear their masks as part of the festivities.

**2.** Africans have a long tradition of storytelling. African folk tales often explain events in nature such as why the spider spins a web. Read some African myths to the class. Next, brainstorm to develop some questions about nature that myths might answer. Have the students pick one of these questions and create a myth to respond to it. Perhaps they would like to act it out.

**3.** The people of Benin honored musicians who played drums, flutes, horns, and a variety of rattles and percussion instruments. Have students bring in empty coffee tins and oatmeal boxes. Then have them create their own instruments by filling the containers with dried beans or seeds, sealing them, and decorating them.

Now try them out. Ask a student leader to tap out a rhythm for the rest of the class to repeat. You might divide the class into different rhythms and see if they can keep them going at the same time, or have students add some dance movements.

**4.** The continent of Africa has an abundance of landforms. It is made up of high mountain ranges, deserts, savannas, rainforests, and jungles. Make an outline of the African continent on a large piece of poster board. Have committees of students representing different landforms place pictures (either drawn or cut from magazines) of their terrain in the appropriate parts of the map. They may also add pictures of the animals that inhabit their terrain.

# CULMINATING ACTIVITIES

◆◆◆◆◆◆◆◆◆◆◆◆◆◆◆◆◆◆◆◆◆◆◆◆◆◆◆◆◆◆◆◆◆◆◆◆◆◆◆◆◆

**1.** Have a Back in Time day. The class might be divided into groups corresponding to the eight cultures featured in this book. Students could dress in the costumes of their culture and bring in food that might have been eaten at that time. Each committee could prepare a song, poem, work of art, game, or some other entertainment relating to its civilization. Invite parents and others classes to attend.

**2.** Create a class newspaper, *The Ancient Times*. You might have a different edition for each culture. The paper could include sections such as News of the Day, Sports, Entertainment, Editorials, Gossip, Employment Opportunities, Lost & Found, Personals, and Cartoons. Don't forget the crossword puzzle!

**3.** Have students create a board game about a civilization using Qin's Challenge as a model. A game called *Cave In!* might focus on the dangers of excavating prehistoric caves. *Treasures of Tutankhamun* could highlight some of the artifacts found in Tutankhamun's tomb. Make sure students include lots of facts about the art and culture featured in their game.

**4.** Have students develop a more detailed time line which shows events that were occurring in the rest of the world when the eight masterpieces were created. They could note inventions, explorations, wars, and other great works of art.

**5.** The eight cultures in the book all reflect certain human needs and aspirations. Comparisons could be made in the following areas:

> Food
> Dress
> Architecture
> Modes of communication
> Religion
> Entertainment
> Transportation
> Attitudes toward natural world
> Use of myths and storytelling
> Geographical setting

# Time Line

Prehistoric
15,000 B.C.

Minoan
1500 B.C.

Egyptian
1325 B.C.

Chinese
210 B.C.

Pompeian
79 A.D.

Maya
700 A.D.

Pueblo
1200 A.D.

Benin
1600 A.D.

2000 A.D.

# Treasure Map

Where were they found?

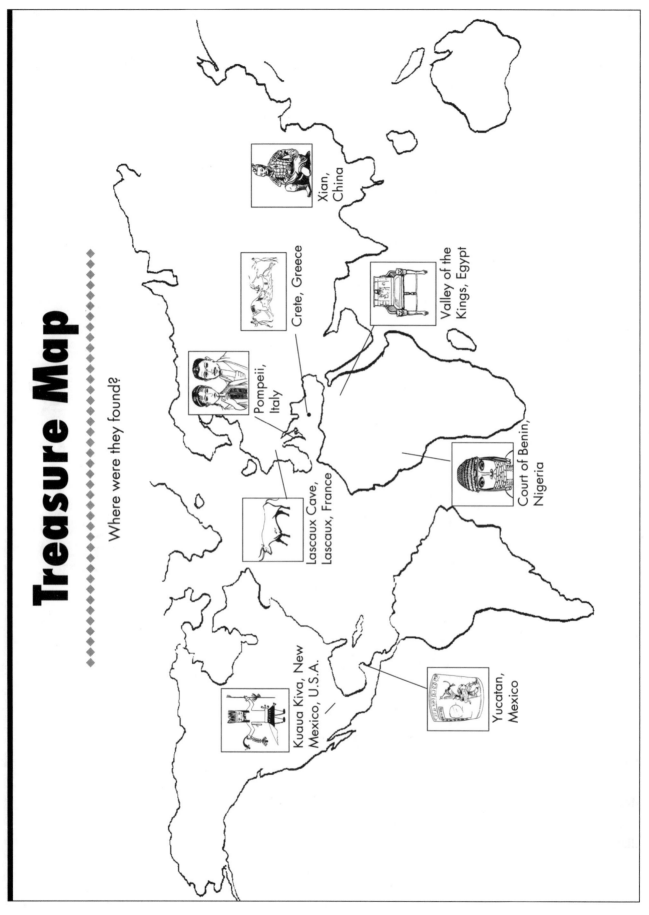

Xian, China

Crete, Greece

Valley of the Kings, Egypt

Pompeii, Italy

Lascaux Cave, Lascaux, France

Court of Benin, Nigeria

Kuaua Kiva, New Mexico, U.S.A.

Yucatan, Mexico

# WORD BANK

◆◆◆◆◆◆◆◆◆◆◆◆◆◆◆◆◆◆◆◆◆◆◆◆◆◆◆◆◆◆◆◆◆◆◆◆◆

**adobe**—sun-dried clay used as a building material

**afterlife**—a life after death

**amphitheater**—a circle of stone seats built around an open arena

**ancestor**—one from whom a person is descended

**ankh**—Egyptian symbol of life

**antechamber**—an outer room leading to a more important room

**archaeologist**—a person who studies human cultures of the past

**archer**—one who uses a bow and arrow

**attendant**—a person who serves or waits upon another

**aurochs**—early bull-like animal that is now extinct

**bronze**—a metal made of tin and copper

**cartouche**—oval shape enclosing Egyptian figures that represent an important person's name

**chariot**—an ancient horse-drawn vehicle with two wheels

**charioteer**—one who drives a chariot

**civilization**—the type of culture and society developed by a particular group of people

**cobra**—poisonous snake with a hooded head

**coral**—a hard, stony material made of the skeletons of tiny sea creatures that is often reddish in color

**Cro-Magnons**—earliest people with same physical characteristics as modern human beings

**crossbow**—a bow that can shoot stones

**culture**—the customs, ideas, arts, and beliefs of a group of people

**descendant**—a later member of the same family or group of people

**discus**—a large, flat, circular object made of metal or stone that is used in athletic events

**dynasty**—a series of rulers from the same family

**excavate**—to dig up

**fresco**—kind of wall painting where color is applied to a freshly plastered wall

**gladiator**—a man trained to entertain the public by fighting, often to the death

**glyph**—carved or painted symbol

**graffiti**—drawings or words scrawled on a wall or building

**headdress**—an elaborate covering for the head

**hieroglyphics**—picture writing

**jade**—a light green stone

**kachina**—Pueblo spirit

**kiva**—sacred room used by the Pueblo for religious ceremonies

**labyrinth**—a maze

**loincloth**—a strip of cloth wrapped around a person from the waist to the top of the thigh

**Magdalenian**—period during which people lived in caves and had simple flint and bone implements

**maize**—type of corn

**mastaba**—an ancient Egyptian tomb with sloping sides and a flat roof

**Mesoamerica**—the area of Central America that includes Mexico, Belize, Guatemala, and Honduras

**Minos**—king of ancient Crete

**Minotaur**—mythic monster that was half man and half bull

**missionary**—person sent by a church to a foreign land to teach his or her religion to those who do not believe in it

**monument**—a building, statue, or other object made to honor a person or event

**mosaic**—a pattern or picture made from small pieces of colored glass or shell

**mudfish**—a fish that can burrow into the mud

**mummy**—a body preserved for burial

**mural**—a wall painting

**nobility**— people of high rank or title

**Oba**—ruler of Benin

**palaestra**—Roman open-air gymnasium

**papyrus**—a tall marsh plant which was cut into strips and dried to make a smooth surface for writing

**pharaoh**—ruler of ancient Egypt

**pigment**—powdered color that can be mixed with water or oil to make paint

**plantain**—a kind of banana

**plaque**—a flat slab made of material such as metal or stone that is decorated and hung on a wall or monument

**pok-a-tok**—ball game played by the ancient Maya

**polychrome**—decorated with more than one color

**prehistoric**—the time before written history

**pueblo**—multistoried dwelling made of stone or adobe

**pyramid**—a stone or brick structure with a square base and sloping sides that meet at the top

**sacred**—holy

**sarcophagus**—a coffin or container for a coffin made of stone, marble, or clay

**scholar**—an educated person

**scribe**—a person employed to write and keep records

**scroll**—a roll of papyrus or skin with pictures or writing on it

**shadow boxing**—a Chinese martial art

**sphinx**— an imaginary creature having the head of a man and the body of a lion

**spirit**—any supernatural being

**Stone Age**—the age of history marked by the use of stone tools

**stylus**—instrument used to write on clay or wax tablets

**toga**—loose outer garment worn by citizens of ancient Rome

**tradition**—thoughts and behavior that are passed from one generation to the next

**tunic**—long, simple slip-on garment that is belted at waist

**wicker**—thin twigs that are easily bent and woven

**Add your own words and definitions below.**

# BIBLIOGRAPHY

◆◆◆◆◆◆◆◆◆◆◆◆◆◆◆◆◆◆◆◆◆◆◆◆◆◆◆◆◆◆◆◆◆◆◆◆◆◆◆

## Prehistoric Art

Bohn, Paul G., & Jean Vertut. *Images of the Ice Age.* London: Bellew Publishing Co., 1988.

Delluc, Brigitte & Gilles. *Discovering Lascaux.* Bordeaux, France: Sud Ouest, 1990.

Kempe, David. *Living Underground: A History of Cave and Cliff Dwelling.* London: The Herbert Press, 1988.

Ruspoli, Mario. *The Cave of Lascaux: The Final Photographs.* New York: Harry N. Abrams, Inc., 1987.

*For children:*

Epstein, Sam & Beryl. *All About Prehistoric Cave Men.* New York: Random House, 1959.

Watson, Lucilla. *An Ice Age Hunter.* Florida: Rouke Enterprises, Inc., 1987.

## Minoan Art

Attenborough, David. *The First Eden.* Boston: Little Brown & Co., 1987.

Edey, Maitland A. *Lost World of the Aegean.* New York: Time-Life Books, 1975.

*For children:*

Gallant, Roy A. *Lost Cities.* New York: Franklin Watts, 1985.

Millard, Anne. *Ancient Civilizations.* New York: Warwick Press, 1983.

Ventura, Piero, & Paolo Casarani. *In Search of Ancient Crete.* New Jersey: Silver Burdett Co., 1985.

## Egyptian Art

Erman, Adolph. *Life in Ancient Egypt.* New York: Dover Publications, Inc., 1971.

Oliphant, Margaret. *The Egyptian World.* New York: Warwick Press, 1989.

White, Jon Manchip. *Everyday Life in Ancient Egypt.* New York: G.P. Putnam's Sons, 1977.

*For children:*

Cohen, Daniel. *Ancient Egypt.* New York: Doubleday & Co., 1990.

Donnelly, Judy. *Tut's Mummy Lost & Found.* New York: Random House, 1988.

Robinson, Charles Alexander. *Ancient Egypt.* New York: Franklin Watts, Inc., 1984.

## Chinese Art

Cotterell, Arthur. *The First Emperor of China.* New York: Holt, Rinehart & Winston, 1981.

Guisso, R.W.L., Catherine Pagani, & David Miller. *The First Emperor of China.* New York: Birch Lane Press, 1989.

Nancarrow, Peter. *Early China and the Wall.* Minneapolis: Lerner Publications, 1980.

*Qin Shi Huang Pottery Figures of Warriors and Horses.* Shaanxi, China: Museum of Qin Shi Huang Pottery Figures of Warriors and Horses, 1989.

Tranchow, Fu, ed. *Wonders from the Earth: The First Emperor's Underground Army.* San Francisco: China Books and Periodicals, Inc., 1989.

*Treasures from the Bronze Age of China.* New York: Metropolitan Museum of Art, 1980.

## Pompeian Art

Bisel, Sara C. *The Secrets of Vesuvius.* New York: Scholastic, Inc., 1990.

Connolly, Peter. *Pompeii.* Oxford: Oxford University Press, 1979.

Etienne, Robert. *Pompeii: The Day a City Died.* New York: Harry N. Abrams, Inc., 1992.

Grant, Michael. *The Cities of Vesuvius: Pompeii and Herculaneum.* Harmondsworth, Middlesex, England: Penguin Books, Ltd., 1971.

*For children:*

Biel, Timothy Levi. *Pompeii.* California: Lucent Books, Inc., 1989.

Goor, Ron & Nancy. *Pompeii: Exploring a Roman Ghost Town.* New York: Thomas Y. Crowell, 1986.

## Maya Art

Coe, Michael D. *The Maya.* New York: Thames & Hudson, Inc., 1984.

Meyer, Carolyn & Charles Gallencamp. *The Mystery of the Ancient Maya.* New York: Atheneum, 1985.

Schele, Linda & Mary Ellen Miller. *The Blood of Kings.* New York: George Braziler, Inc., 1986.

Whitlock, Ralph. *Everyday Life of the Maya.* New York: Dorset Press, 1976.

*For children:*

McKissack, Patricia C. *The Maya.* Chicago: Childrens Press, 1985.

Odjik, Pamela. *The Mayas.* New Jersey: Silver Burdett Press, 1990.

## Pueblo Art

Dutton, Bertha P. *Sunfather's Way: The Kiva Murals of Kuaua.* New Mexico: University of New Mexico Press, 1963.

Maxwell, James A., ed. *America's Fascinating Indian Heritage.* New York: The Reader's Digest Assoc., Inc., 1992.

Tamarin, Alfred, & Shirley Glubok. *Ancient Indians of the Southwest.* New York: Doubleday & Co., 1975.

*For children:*

Erdoes, Richard. *The Pueblo Indians.* New York: Funk & Wagnalls, 1967.

## Benin Art

Ben-Amos, Paula, & Arnold Rubin. *The Art of Power, the Power of Art: Studies in Benin Iconography.* California: Museum of Cultural History, UCLA, 1983.

Ezra, Kate. *Royal Art of Benin: The Perls Collection.* New York: Metropolitan Museum of Art, 1992.

Freyer, Bryna. *Royal Benin Art in the Collection of the National Museum of African Art.* Washington, D.C.: Smithsonian Institution Press, 1987.

*For children:*

Elliot, Kit. *Benin: An African Kingdom and Culture.* Minneapolis: Lerner Publications, 1979.